VAN GOGH

VAN GOGH

W. Uhde

with notes by Griselda Pollock

This edition published by Borders Press, a division of Borders Group, Inc., 100 Phoenix Drive, Ann Arbor, Michigan, 48108, by arrangement with Phaidon Press Limited.
Borders Press is a trademark of Borders Properties, Inc.

© 1951 Phaidon Press Limited

ISBN 0-681-46303-1

Printed in Singapore

Cover illustration:
Vincent van Gogh. *Still Life: Sunflowers*, August 1888 (Plate 22)

The publishers wish to thank all private owners, museums, galleries and other institutions for permission to reproduce works in their collections.

Van Gogh

When the name of Vincent van Gogh is mentioned we are reminded of a number of brilliant pictures, but at the same time we think of the shadows of a pitiful life which its bearer dragged like a cross to an untimely Golgotha. Art and life are here so closely interwoven, so inseparably bound up with one another, that we cannot attempt to describe them separately, as is so often done in monographs on artists. Moreover, Van Gogh's life was not subordinated to the rules of any period or milieu, his work followed no one direction or programme. Both were unusual and in their way unique. The name of Van Gogh suggests primarily no theme connected with the history of art, but rather an eminently human one. He was a missionary who painted. He was a painter with social ideas. His story is not that of an eye, a palette, a brush, but the tale of a lonely heart which beat within the walls of a dark prison, longing and suffering without knowing why, until one day it saw the sun, and in the sun recognized the secret of life. It flew towards it and was consumed in its rays.

This pathway from coldness to warmth, from mist to brightness, from the north to the south, had been trodden by many others before Van Gogh, but in a very different way. With what dignity, what thoughtfulness and care in registering every stage did Goethe follow it! But Van Gogh rushed towards the fatal glow thoughtlessly and with childlike haste, almost like a modern Icarus.

The tragedy of his brief life lies in the fact that he spent most of it seeking amidst sorrow, pain and despair after the simplest, the most obvious thing in existence, the sun, and that he died as soon as he had found it. For none of his predecessors had the way been so difficult, the transition of the northern man from the world of literature, of ideas, of morality and social problems to the sensual world of pictures. No one before him had sought so passionately after what he did not possess. One element of the southern clime was innate in his dark and frigid origin; the Mistral, that wind which can lift stones from the ground and carry them away. He had the Mistral in his heart, and borne on its wings he set out to find the rest: the sun and colour.

His life is the story of a great and passionate heart, which was entirely filled with two things: love and sorrow. Love, not in the sense of likings or preferences, of sympathy or aesthetic taste, but in its deepest form, charity, a deep religious relationship to men and things. Here is the root of his life and art. This love of his led him to self-sacrifice, to a prodigal spending of his own ego. His life was an uninterrupted giving of himself, and his painting was nothing but the most adequate means of giving himself which he discovered after many other attempts.

This impetuous devotion, this religious form of action, were in him of an unusual grandeur, and the greater they became, the harder seemed to him those words of Spinoza which in his case became a terrible truth: 'He who loves God cannot expect to be loved by God

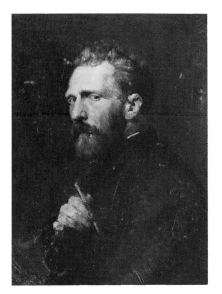

Fig. 1
John Russell: Portrait
of Vincent van Gogh
Oil on canvas, 60 x 45 cm.
1886. Amsterdam,
Rijksmuseum
Vincent van Gogh

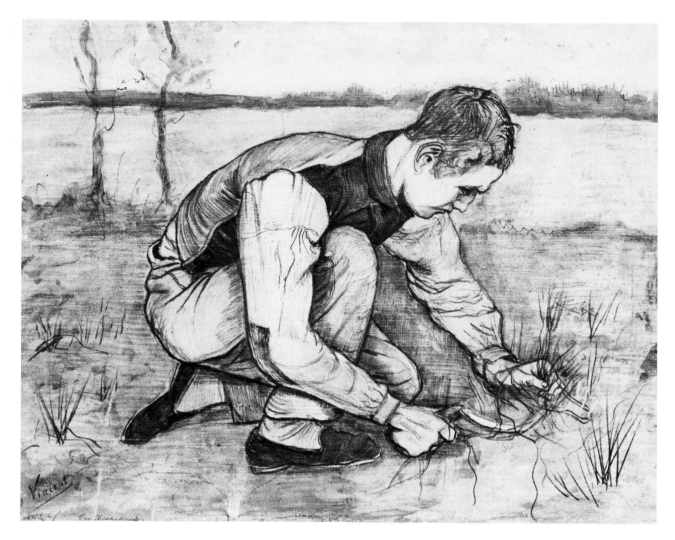

Fig. 2
Young Peasant with a
Sickle
Black chalk and water-
colour on paper,
47 x 61cm. 1881. Otterlo,
Rijksmuseum
Kröller-Müller

in return.' The violence of this love of his did not bring him within the community of men, it separated him from them and made him suspicious and lonely. Thus, together with love, a second feeling entered his heart: sorrow, not indeed in the lighter form of melancholy, but in the graver form of deep suffering and often of despair. It was interwoven into the web of his short life as an essential and inseparable part. Just as his religious love for the poor, the weak and the sick was not reciprocated, so was it also with his earthly loves. He loved three women. The first made fun of him, the second ran away from him, the third, who was really fond of him, tried to take her own life. But his last great love was for the sun, which he glorified in his pictures. Men would have nothing to do with these pictures and laughed at them. And even the sun did not love him, it robbed him of his reason and killed him.

If ever a life was tragic, Vincent's was certainly so. Only one man understood him, loved him and helped him: his brother Theo, four years his junior. At the most difficult moments Theo was always there, consoling him in his despair, suggesting new ways when he appeared to have reached an impasse, encouraging him in his creative work. Theo sacrificed his money, submitted patiently to all the unbearable, incalculable, contradictory, evil and capricious characteristics which became manifest in his elder brother as the process of self-destruction continued. Love, friendship and admiration aided him in his task. Yet one day he had to listen to the terrible words, uttered from the depths of suffering: 'You can give me money, but you can't give me a wife and children.'

Above the story of Vincent van Gogh's life, which lasted thirty-

seven years, one might place as motto the words which he himself uttered at the deathbed of his father: 'Dying is hard, but living is harder still.'

Of his works, the production of which occupied barely ten years of his life, one might say what Dr Gachet, who attended him in his last days, wrote of him: 'The words "love of art" are scarcely applicable to him, one ought to say: belief even unto martyrdom.'

Vincent van Gogh was born on 30 March 1853, at Groot-Zundert in Holland. His birthplace lay in the midst of flat country beneath a low sky, intersected by canals which might have been drawn with a ruler. The life of its inhabitants was narrow and provincial, for they were good bourgeois whose existence was easy and free from troubles; they followed the precepts of law, custom and the ten commandments. It was also considered a virtue to be 'well-bred'. Vincent grew up in an old-fashioned country house with many windows, in the company of a number of younger brothers and sisters. His father was a clergyman, by nature and profession helpful, good-tempered and considerate. His mother, with whom he had a great inward affinity, was named Anna-Cornelia Carbentus. The material position of the family was very modest.

The red-haired boy was not handsome. What distinguished him most in these surroundings was his temperament, which was the exact opposite of everything around him, for he was unsociable, passionate, undisciplined and retiring. A warm relationship existed from the earliest days between him and his younger brother Theo.

When he was twelve years old, he was sent to a boarding school at Zevenbergen. At sixteen, he returned to his parents' house. His sister describes how at this time he used to escape from the tedious life of the sleepy village and take refuge in the open country to avoid the eyes of his father's inquisitive parishioners: 'Broad rather than tall, his back slightly bent owing to the bad habit of letting his head hang forward, his reddish fair hair cut short beneath a straw hat, which overshadowed an unusual face: not at all the face of a boy. His brow was already slightly wrinkled, his eyebrows drawn together in deep thought across the wide forehead; his eyes small and deep-set, sometimes blue, at other times greenish, according to his changing expressions. Despite this unattractive, awkward appearance, there was yet something remarkable in his unmistakable expression of inward profundity.'

Even then his parents had a feeling that there was something unusual about their son and they felt a presentiment of the trouble he would later be to them. As they walked along the lonely country road to visit the sick, they often used to stop and discuss the future of their eldest child. Their first step was to send him to The Hague, where they obtained, through the influence of his father's brother Vincent, who was connected with the firm, a post for him as salesman in the branch there of the Paris firm of Goupil. The works sold by the firm were sentimental genre paintings of the type to be seen at that time in the Paris Salon, but there were also among them lithographs of Corot's pictures. Vincent was clever at packing and unpacking books and pictures, and for three years he performed his duties in an exemplary manner. When he was twenty years old, he was sent to the London branch. There he employed his free weekends in drawing, modestly, for his own amusement. He sent these sketches to his mother and Theo. In London he had plenty of opportunities for studying art, for seeing all kinds of works, for developing his taste. The result was disastrous. What he preferred were pictures by Mauve, Ziem, Boldini, Meissonier, Knaus, Israëls and one or two sickly religious painters. Even when names like Constable and the

painters of the Barbizon school appear among his preferences, we can only conclude that he was attracted by their choice of subjects, and not by their artistic merit. At this time his artistic perceptions were obviously still unawakened, he had no feeling for class or quality; his one preoccupation was to find satisfaction in the contents of the pictures.

The inward peace of mind in which he then lived was broken when he fell in love with the daughter of his landlady, a widow named Loyer. This girl led him on and finally told him that she was already engaged. The neurasthenic condition into which this adventure plunged him was not without subsequent effects on his relations with the Goupil Galleries, both in London, where he was dismissed, and in Paris, where he obtained another post through his connection – after a short unhappy stay at home and another visit to London. He was tactless in his dealings with customers, whose taste he criticized and who did not want to be served by the 'Dutch peasant'. Nor were his employers pleased when he informed them that trade was nothing but organized theft. In Paris he remained for two months, and then, after another short visit to London, he spent the years 1875 and 1876 in the French capital. Although he continued to work at Goupil's his attitude to artistic matters had changed. He did not like his work, was not interested in the beautiful city, which gave him nothing, and lodged in a room in Montmartre, where he read the Bible with a young Englishman, discussing its contents for hours on end. He often went to the English Church, and thought of devoting his life to the poor. The result was that he finally left Goupil's for good.

His anxious father came to Paris and made proposals which did not meet with Vincent's approval. Theo advised him to become a painter, but even this idea, which had occupied Vincent's mind earlier at one moment in London, was now rejected. His education was superficial and chaotic, and he was not suited to any ordinary profession. In 1876 he went back to London and obtained a post *au pair* at Ramsgate, as French teacher in a school owned by a grotesque pedant, who had about twenty pale and underfed boarders in his house. Vincent had to collect the school fees from the parents, who lived in Whitechapel, and thus gained an insight into the housing conditions of the poor. He lost his job when he returned without having got the money. Then he went to London to the house of a Methodist preacher, who kept a rather better boarding school and with whom he had eager discussions on religious matters. He himself preached bad sermons, and when he was ill, he praised illness and found sorrow better than joy. The idea of consoling those who are unfortunate in this world became stronger and stronger in his mind.

Christmas of this year he spent in Etten, where his parents were now living. He was gloomy and restless, and they breathed a sigh of relief when he went away again. Through his uncle Vincent he obtained a post as apprentice in a bookshop at Dordrecht. At this period he lived like an ascetic, wore Quaker clothes and gave himself up entirely to piety. Despite these sorrowful and gloomy moods he still took an interest in the landscape surrounding him, which sometimes found enthusiastic expression, and we may assume that now and then he made sketches of it. But at this time drawing was probably no more to him than the song a traveller whistles as he tramps alone along a dusty country road. How poor his understanding for art then was, is proved by the fact that in the small town museum a trashy *Christ in the Garden of Gethsemane* by Ary Scheffer was the only thing to excite his admiration.

He did not stay long in Dordrecht. He was now determined to

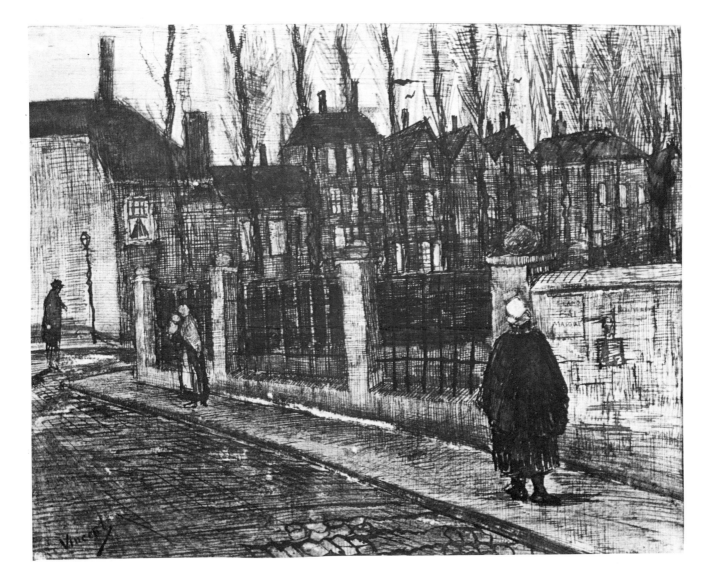

Fig. 3
The Paddemoes
in The Hague
Pen and ink and pencil on
paper, 25 x 31 cm. 1882.
Otterlo, Rijksmuseum
Kröller-Müller

become a pastor. For this a university degree was necessary, and first he had to fill in the gaps in his education and sit for an examination. He lived in Amsterdam with an uncle of his who was an admiral and who alienated him by his martial bearing. For fourteen months Vincent worked perseveringly, and we find him spending the hot summer afternoons struggling with Greek dictionaries. But he could not manage it; he withdrew from the examination and decided to become a preacher on his own account. He left Amsterdam and went to prepare himself at the evangelical mission school in Brussels. After three months it was found impossible to give him a definite appointment, but he was allowed to go as an independent missionary on his own account and at his own risk to the Borinage, a coal-mining district. He went to Pâturages, a village near Mons, that same Mons where Verlaine had been imprisoned only three years before. Then he received an appointment for six months in the neighbouring village of Wasmes. Taking the lives of the early Christians as a model, he gave everything he possessed to the poor, went about in a worn soldier's coat, wore no stockings, made his own shirts out of old pack-cloth, and slept on the ground in a wooden hut. He looked after the miners when they returned exhausted after twelve hours' work underground, or when they had been injured by explosions in the pits; he helped the sick during an epidemic of typhus. He preached too, but he had not the gift of public speaking. He devoted himself entirely to his work, ate bad food, became weak and thin. But he would not give up half-way. His father, although he was himself a

clergyman, could not understand this eccentric behaviour; he came to see him, pacified the wayward son with whom it had pleased God to burden him, and took lodgings for him at a baker's. Even the religious body which had given him the appointment were appalled at his 'excess of zeal', and recalled him under the pretext that his sermons were not good enough.

It is characteristic of the contradictions in his nature that his first pictures date from this very time when he could exclaim: 'Christ was the greatest of all artists', and that it was then that he spoke a great deal about painting and wrote to his brother: 'I often long to go back to pictures.' He did a number of watercolours and drawings of the life of the miners. Now began the struggle between his religious aspirations and his artistic tendencies, which he was unable to reconcile. When the latter finally won the victory, it was only after many inward struggles and terrible relapses.

Returning to Etten, he found consolation in his father, and painted flowers, which he had always loved. But a short time afterwards he went back again to the black country and wandered about the roads with bleeding feet, half saviour, half tramp, sleeping in the open air: when he arrived back in the Borinage his despair knew no bounds. Then suddenly the other tendency asserted itself; he wanted to become a painter, he spent all his time drawing, and he wrote to his brother, who was at Goupil's in Paris, that he wanted to get out of this 'dreadful, very dreadful cage'. He appealed to their mutual, very sincere affection and regained his brother's confidence. They met at Etten. Vincent spent the winter in Brussels drawing and studying in the Museum. It was now 1881 and he was twenty-eight years old. Then an unfortunate love affair with a cousin at his home once more disturbed his peace of mind.

Vincent next went to The Hague, where he remained for two years. He painted in the house of his cousin Mauve. But this relationship gave Vincent no satisfaction. Visits to the Mauritshuis contributed to his artistic education. One may suppose that here for the first time a feeling for quality showed itself in him, that it was no longer the social element, the religious legend, which interested him, when he stood long before the pictures of Rembrandt. He was on the right path, but at the beginning of 1882 an event occurred which plunged him back into the depths of self-abasement. He got to know a drunken woman who had spent her life in a state of moral and physical misery. He brought her and her children to live in his house and used her as a model. She drank and smoked cigars while he had to go hungry. There is a sketch by him, called *Sorrow*, in which we see her crouching hopelessly on the ground, with withered breasts. What his real feelings were for this woman is clear from the quotation from Michelet which he wrote on the sketch: 'How can there be lonely, deserted women in the world?' This relapse into the sphere of religious and social ideas lasted eighteen months. Once again it was Theo who came and set him free. It was difficult for Vincent after this experience to rediscover his intimate connection with the brighter realms of art. He began to wander about and came to Drenthe, a lonely, impoverished place. It seems that here he felt the first symptoms of madness. The cross which he had taken up of his own free will, first in the Borinage and now with this woman, had borne him down to the ground. At the end it seemed as if he could not rise again. In the religious sense he had perhaps reached a wonderful climax, but from the worldly point of view, that is to say as understood by all good citizens and pastors, it was an unbridgeable gulf. He dragged himself back to his parents' house, defeated, a prodigal son who had wasted the treasures of his heart in orgies of

misery, in a drunken feast of self-sacrifice.

In Nuenen, where his parents were now living, he regained strength enough to pull himself together and resume painting in an atelier which he had fitted up in a church. His sister describes his appearance at this time: 'Carelessly dressed in the blue smock of a Flemish peasant, his hair cut short, his reddish-brown beard unkempt, his eyes often inflamed and red from staring at some object in the sunlight, his hat with its soft brim pressed right down over his eyes.' Another unhappy love affair came to disturb him, and in addition to this, in 1885 his father died.

Vincent now spent all his time painting: the deep sky, the wide plains, the low houses of the country. He painted in dark, heavy colours which even at this time he was fond of contrasting and weighing against one another. The figures and land in these paintings were Dutch. He had been reading Zola and his love for the land had been strengthened thereby. At this time Daumier had significance for him, probably because he liked his dark prevailing tone, and perhaps also because a human and social element was manifest in his works. The worthy Breitner had taught him to paint 'well', in the sense of the old Dutch masters. Nuenen denotes the first period of his art; what had gone before need not be considered. But this art remained 'provincial' and through it he could never have achieved eternal fame. The most typical picture from this period is *The Potato-Eaters*. If we compare it with Le Nain's pictures of peasants, we obtain an idea of how much was still to be done.

Now he proceeded by rapid stages towards his artistic maturity.

Fig. 4
Miners Going to Work
Pencil on paper,
44.5 x 56 cm. 1880.
Otterlo, Rijksmuseum
Kröller-Müller

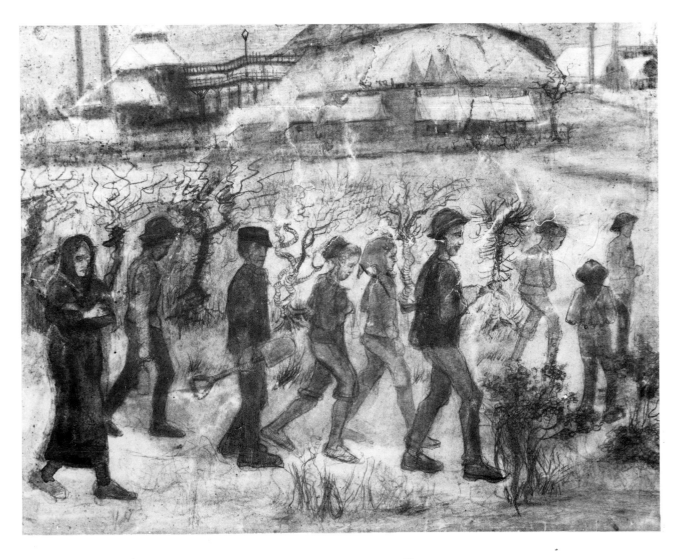

He had little time to lose. Only six years remained until his death. The first stage in the journey was Antwerp, where he arrived when he was thirty-one years old. The gay and varied life of the city filled him with pleasure. He attended the painting classes at the Academy, but his colours dripped from the canvas to the floor. 'Who are you?' asked the indignant teacher. 'I am Vincent the Dutchman,' he shouted back, and was transferred to the drawing class. In Antwerp he was able to study works of Rubens and the Japanese artists. Under their influence he gave up using dark colours; his palette became lighter. The study of Hokusai's *Hundred Views of Fujiyama* gave his pencil accuracy and style.

After three months he had exhausted Antwerp. In February 1886 Theo, who was still at Goupil's, received a note from his brother fixing a rendezvous in the Salon Carré at the Louvre. The two brothers went to live together. Vincent worked at Cormon's atelier, where he got to know Toulouse-Lautrec and the young Emile Bernard, with whom he remained afterwards in close touch and maintained an interesting correspondence. Up till now he had only known the Dutch painters, and among the French only Millet, Daumier, the Barbizon school, Monticelli. Now he saw Delacroix and the Impressionists. Manet had been dead for three years, but the others were at the height of their careers and of their art. And they were the centres of attraction. At Goupil's he made the acquaintance of Gauguin and saw pictures by Degas which he did not like. More interesting for him was Père Tanguy's shop, where paintings by Pissarro, Cézanne, Renoir, Sisley, Seurat, Guillaumin and Signac were to be found. He got to know these painters and took part in the discussions they held in the shop. Here were revelations for him: light, colour, a new technique. That of Seurat influenced him especially. He saw with different eyes, absorbed and learned. With his brother he soon moved to Rue Lepick, where they had a view of the Moulin de la Galette and their little restaurant, kept by Mère Bataille, where besides themselves Mendès, Willette and Jaurès took their meals. Vincent soon left Cormon's atelier. He worked in the streets, at Montmartre, in the environs of Paris, at Chatou, Bougival and Suresnes. He painted the little restaurants in the bright colours of spring, in bright blue and pink. He painted the yellow still life with the candle and the sealed letter, he painted Père Tanguy and other portraits (Plate 7). Paris awakened and liberated his sensuality. Only rarely, as in the celebrated *Courtyard of a Prison*, did a more thoughtful social note appear.

But the winter was hard. There came bad moods and crises of neurasthenia. Then too it suddenly became clear that in reality everything was in vain, that these pictures could not be sold. Despite his influential position at Goupil's, Theo was unable to sell a single one of his brother's pictures. There were many quarrels, and the atmosphere became unbearable.

To all the other reasons which induced Vincent to leave Paris must be added this: a subconscious realization that this city was not for him an end and a goal in itself, but only the penultimate stage before that for which all that had gone before had been merely preparation. The Impressionists? Certainly, he used their modes of expression, saw with their eyes, employed their technique; both he and they were inspired by the same Japanese school. But beyond that? They loved the appearance of things and loved them with well-tempered bourgeois hearts. He loved passionately the things themselves. They like brightness. He was a fanatical worshipper of the sun. That was something different, something deeper. He now set out to devote himself to this service of the sun, which was to be the

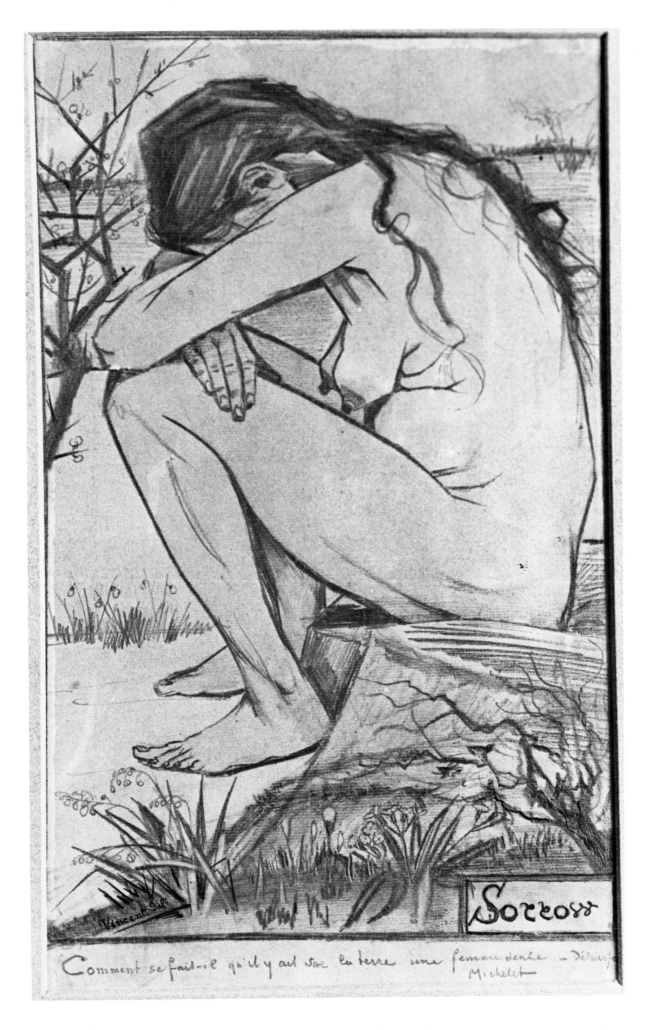

Sorrow

Comment se fait-il qu'il y ait sur la terre une femme seule – Délaissée
Michelet

13

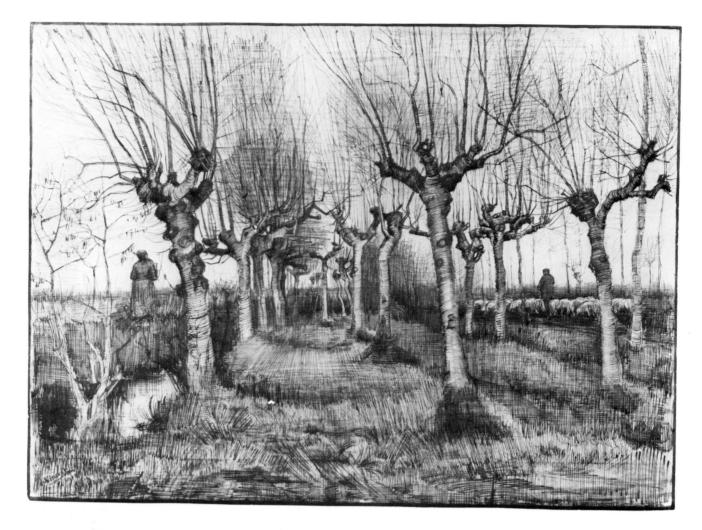

Fig. 6
Pollard Willows and
a Shepherd
Pen, pencil and body
colour on paper, 39.4 x
54.6 cm. 1884.
Amsterdam, Rijksmuseum
Vincent van Gogh

justification of the whole of his previous life. One day his brother found on the table an affectionate letter of farewell.

In February 1888 he arrived at Arles. He took a room in a small hotel, which had a café beneath it. We know from his pictures this café with the billiard table in the middle and the three lamps hanging like suns from the ceiling, while the terrace of the café appears in one of his finest sketches. He painted and drew every day without a pause. He painted the squares and streets of the town, the Aliscamps (Plate 20), the public gardens, the bridge (Plate 13), sunsets over Arles, fields with the railway in the background (Fig. 21). He painted the blossoms of the fruit trees (Plates 27 and 28), gardens with gaily-coloured flowers. He painted white roses in a vase, lemons in a basket; he painted portraits – his own, time after time, the *Berceuse* (Plate 34), the *Arlésienne* (Plate 29), the *Zouave* (Plate 30), the peasants of the Camargue (Fig. 11), the postman Roulin (Plate 33), who was his crony and with whom he used to sit in the little café until late into the night. He went to Les Saintes-Maries-de-la-Mer and painted the sea and the boats (Plate 16). He painted and painted Here in Arles he made himself immortal, he created his work, his *monumentum aere perennius*, the work not of an eye, a palette, a hand, but of a great and generous heart. Only occasionally, when his heart was tired, his hand went on painting, and then empty or decorative elements entered into a few among these hundreds of pictures.

He gave himself completely and lavishly, as he had once done in the Borinage. He rented a house (Plate 12), painted it yellow and adorned it with six pictures of sunflowers (Plate 22). It was to be the 'House of the Friends'. The idea of the communal life of the early Christians kept returning to his mind; he dreamed of artists living

14

together, producing the most beautiful pictures as the fruit of their existence in common.

He remained the deep, sensitive man he had been before. He had not become a 'bourgeois', nor did he become a 'painter'. Something 'sentimental', in the widest and loftiest sense of the word, is the essential element in his art. If we wish to analyse his work we must begin with these values of feeling and expression. He was a lover who penetrated from the surface into the essence, the totality of things. He did not love sunshine: he loved the sun; and it was the latter he wanted to paint, not the former. When he writes: 'how beautiful is yellow', this is not merely the sensual reaction of a painter, but the confession of a man for whom yellow was the colour of the sun, a symbol of warmth and light. Yellow aroused ecstasy first as an idea in the man, then as a colour in the artist. Thus the sunflowers which he painted rise above the significance of ordinary still life, and he himself says that they produce an effect like that of stained-glass windows in Gothic churches.

In his portraits, especially his self-portraits, these values of feeling and expression are to be found in abundance. He himself confessed that he would have preferred above all things to paint pictures of saints, with modern figures it is true, but intimately related to the primitive Christians. But he was afraid of his own emotions. His landscapes too are not reflections of an eye, but actual experiences of a human being. He himself says of them that in one he wished to

Fig. 7
The Potato-Eaters
Lithograph,
26.5 x 30.5 cm. 1885.
Amsterdam, Rijksmuseum
Vincent van Gogh

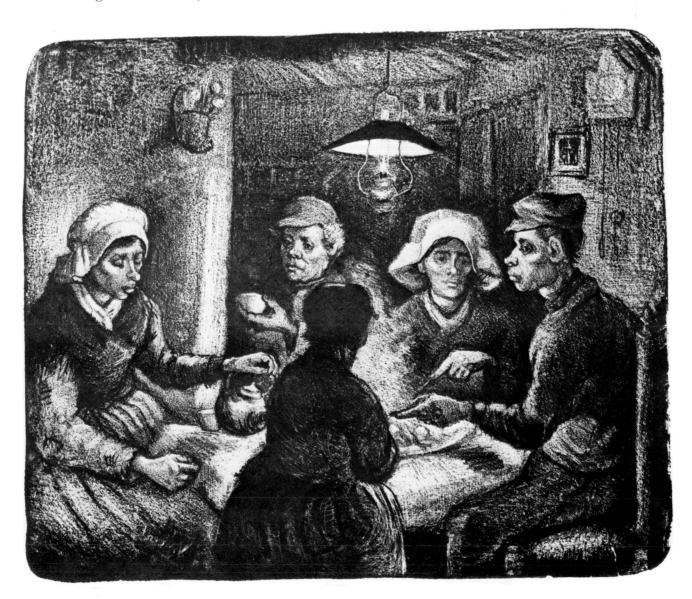

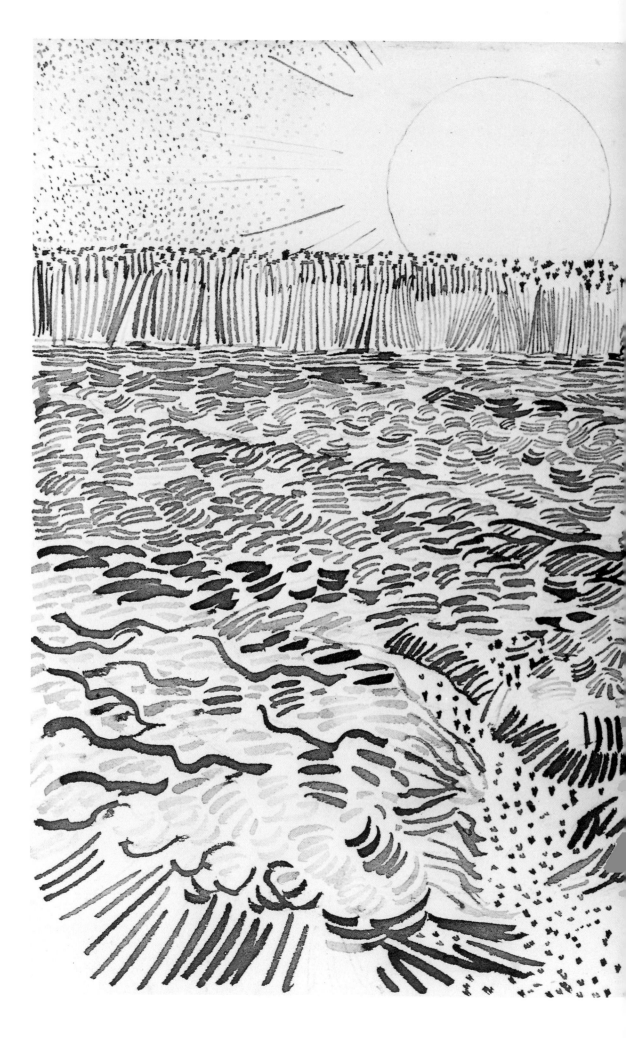

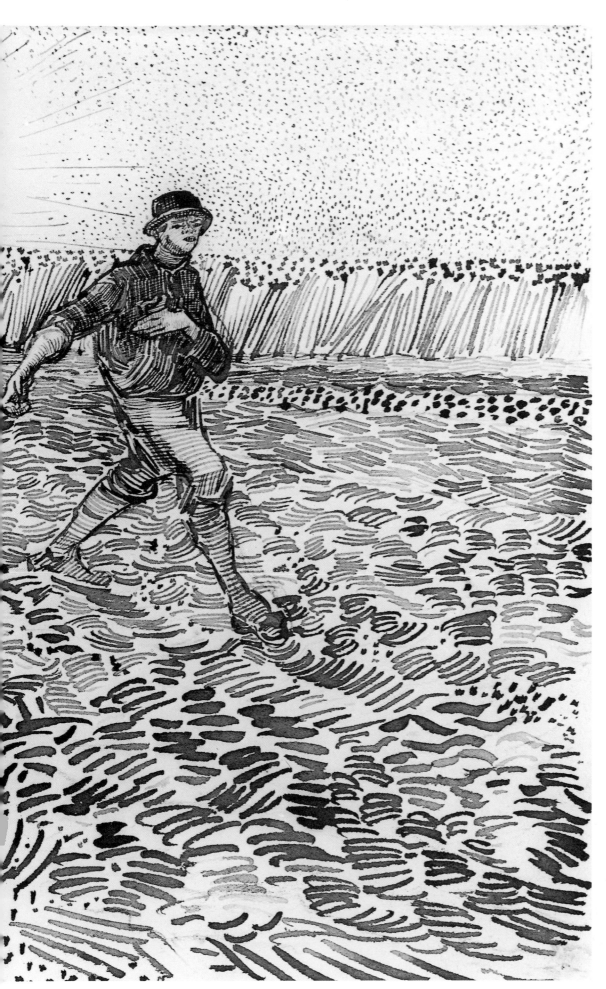

Fig. 8
The Sower
Reed pen and ink on
paper, 24 x 32cm. 1888.
Amsterdam, Rijksmuseum
Vincent van Gogh

express great peace, in another the extremes of loneliness and sorrow. His religious attitude to the world is perhaps most vividly expressed when he paints flowers. His sister wrote of him that even when he was a boy he understood the 'soul' of flowers. He used to tie them together in bundles with a sensitive hand, the same hand with which later he packed books and pictures into cases, and later still tended the wounds of the sick. With this same delicate hand his brush now reproduced not only the appearance but the very soul of flowers. In one of his letters he speaks of the 'sickly greenish-pink smile of the last flower of autumn'. That is the language of a conception which is the direct opposite of that of the Impressionists.

But these values of feeling and expression, which are the first we must note in his pictures, are not mere illustration or literature transferred to canvas, but take their place with the other features of his work and form a dominant note which is expressed with the pure means of painting. Of the other plastic values we must mention his understanding for space (Plate 23 and Fig. 25). He knew how to give an exact impression of distances, not only by means of houses and trees, or by inconspicuous points of contact such as a little cart which – as in the picture of the railway – he places in the middle of the plane, but even by means of the varying forms of furrows in a field.

That the values of movement also play an important role in his works is likewise not surprising when we consider his passionate temperament. It is characteristic that he chose as subjects for copies Rembrandt's *Raising of Lazarus* (Plate 41 and Fig. 35), Delacroix's *Good Samaritan*, Daumier's *Drinkers*, and Millet's *Sower* (Plate 26 and Fig. 28), all of them works containing great energy of gesture. The

Fig. 9
The Public Gardens
in Arles
Pen and ink on paper,
25.4 x 34.3 cm. 1888.
Amsterdam, Rijksmuseum
Vincent van Gogh

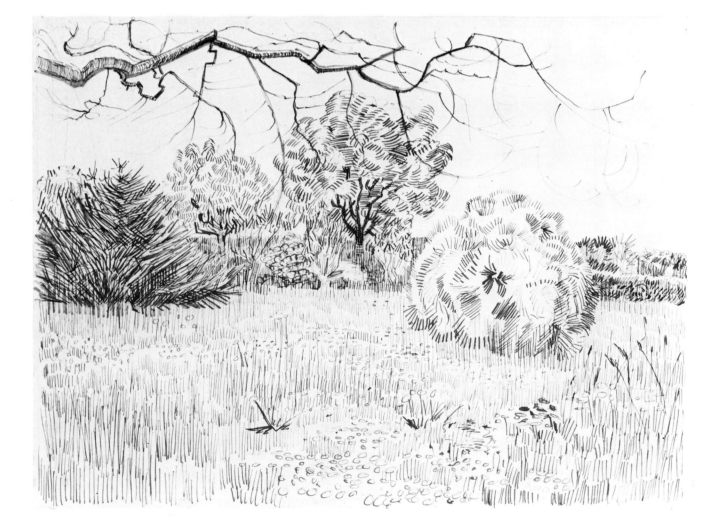

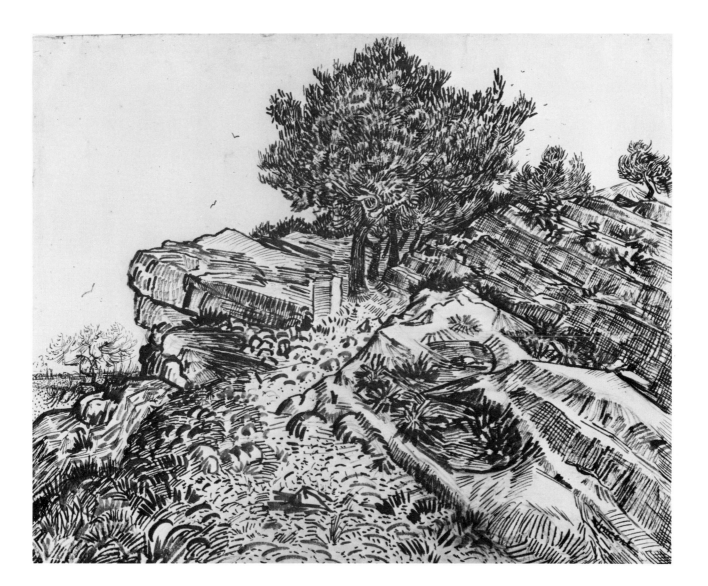

Mistral which never ceased raging in his heart drove him into the open air to face that Provençal Mistral which could bow trees and crops down to earth. Thus was created in the struggle between these forces the *style flamboyant* of those pictures of driving clouds and rustling cypresses.

In making everything comprehensive become reality he was helped by those tactile values which are present in such abundance. He had two ways of realizing his feeling for tangibility: either, like the Japanese, inserting with the most exact draughtsmanship every little detail of ground, boats, rain, sea, etc., or else, on the contrary, by simplifying everything, by omitting the details and only suggesting, as Giotto used to do, the essential form and material of houses, mountains and trees. 'I have tried to retain in the drawing what is essential', he wrote to Emile Bernard, and in the same letter he says that he fills in with simplified colours the surfaces rounded by the outlines. In this way many of his pictures have an exactitude and probability which surpass those of nature.

These values taken together make up the style which is typical of his work. But more than by all these features, we recognize his works by the colour values. His letters from Arles to Emile Bernard, with their descriptions of colouring, abound in the praise of Veronese green, light green, yellow in all its shades from orange to light lemon-yellow, Prussian blue, vermilion, violet and pink. These colours, in which he revels, he places together, contrasts, or combines to form harmonies by the addition of others. A young painter to whom he

Fig. 10
The Rock at
Montmajour
Pencil, pen, reed pen and
ink on paper,
49 x 60 cm. 1888.
Amsterdam, Rijksmuseum
Vincent van Gogh

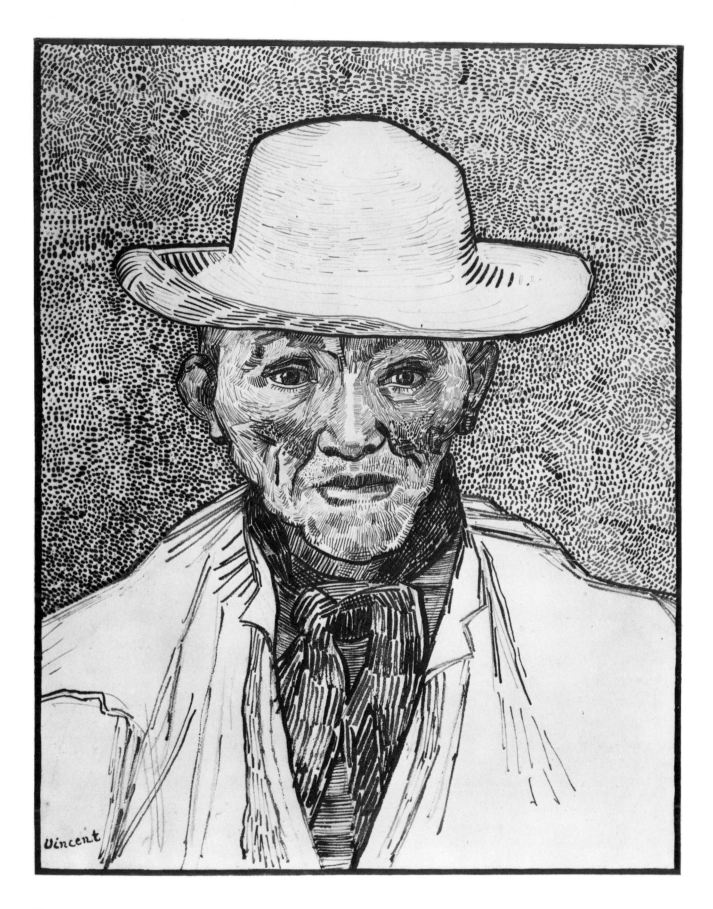

Fig. 11
Portrait of Patience Escalier, a Cowherd of
the Camargue
Pencil, pen, reed pen and ink on paper, 49.5 x 38 cm.
1888. Cambridge, Massachusetts, courtesy of the
Fogg Art Museum, Harvard University, bequest
Grenville L. Winthrop

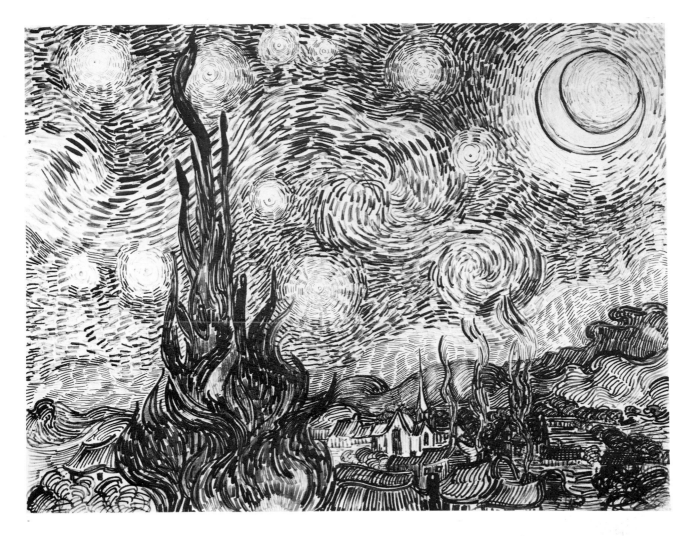

Fig. 12
Starry Sky
Pen and ink on paper,
47 x 62.3 cm. 1889.
Formerly Bremen,
Kunsthalle. Destroyed in
the Second World War

once gave advice relates that Van Gogh was always comparing painting to music, and that he took piano lessons from an old organist in order to determine which tones of the instrument corresponded to Prussian blue, sapphire green, cadmium and yellow ochre.

The beauty of pure colours and their harmonious blending in Van Gogh's works have never been surpassed. It is the beauty and grandeur of nature itself, the equivalent of that which God has created in birds, butterflies, flowers and stones, that beauty which exalts us and fills us with joy. All these colours and harmonies occur in nature just as he paints them or in a similar form. Van Gogh, however, was unable to find sources of inspiration higher than these; they were the limits of his art.

'Oh, the beautiful sun of midsummer! It beats upon my head, and I do not doubt that it makes one a little queer', wrote Van Gogh from Arles. His invitations to visit the 'House of Friends' had been accepted only by Gauguin. They spoke a great deal about art, Gauguin assuming a didactic tone which accentuated the morbid irritability of the other until it reached a crisis. It appears that Van Gogh threw a glass at his friend's head and on another occasion threatened him with a razor. What is certain is that in a moment of mental derangement he cut off his own ear, wrapped it in paper and left it at about three o'clock in the morning in a brothel. While Gauguin left Arles as quickly as he could, Van Gogh was taken to hospital, where his disease took the form of hallucinations. His brother came to visit him there. After a fortnight he became calm again and was able to leave the hospital. But the inhabitants of Arles presented a petition stating that as a dangerous madman he ought not to be left in liberty. He

Fig. 13
A Garden in Provence
Pen and reed pen and ink
on paper,
48.9 x 61 cm. 1888.
Winterthur, Oskar
Reinhart Collection

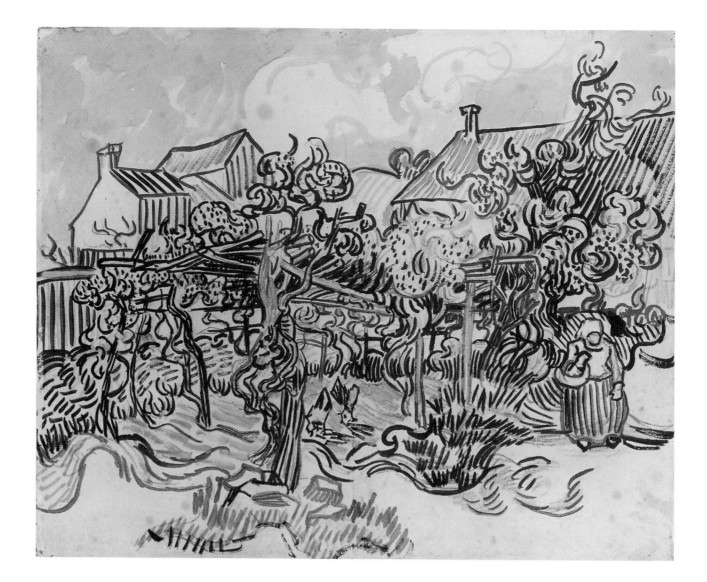

Fig. 14
Old Vineyard with
Peasant Woman
Pencil and wash on paper,
43.5 x 54 cm. 1890.
Amsterdam, Rijksmuseum
Vincent van Gogh

returned to the hospital, and during the next few weeks created some beautiful pictures: several self-portraits, among them the one showing him with his severed ear, the garden of the hospital, the inner room with the stove, the beds and curtains. Signac visited him at this time, and they were allowed to go out together, as far as Van Gogh's house. This short visit wore him out. He himself realized that he would have to go to an asylum, and accordingly he went to that of St Rémy, a few miles away, where he was given two rooms, one of which he used as an atelier. Here he painted a number of wonderful pictures of everything that surrounded him: the house and the garden seen from all angles, landscapes seen from the open window, with cypresses (Plate 42) and olive trees, more self-portraits (Plate 44), the doctor, the attendant (Plate 43). The last intoxication of southern colour came upon him. His letters to Emile Bernard at this time are filled with countless observations on colouring. Here he created some of his maturest and most beautiful works, the copies made from reproductions after Rembrandt, Delacroix, Daumier and Millet. The zenith of his artistic achievement coincided with his first successes. The *Mercure de France* published an appreciative article on his painting and Theo was able to announce what seemed impossible, that he had sold a picture.

In St Rémy peace once more entered into his soul. His clarity of mind and resignation were such that with painful humour he compared the living-room in bad weather to the third-class waiting-room of a remote village station, because some of the patients always wore

their hats, carried walking-sticks and were attired in travelling dress. Nevertheless fresh crises repeatedly afflicted him and during one of these he swallowed a quantity of paints. The sojourn in St Rémy became intolerable to him and at his brother's suggestion he decided to go to Auvers-sur-Oise and place himself in the care of Dr Gachet, a friend of Impressionist painters and their works. On 18 May 1890 he arrived in Paris, where his healthy appearance and cheerful mien were remarked upon. Three days later he reached his destination. Dr Gachet's friendly attitude and admiration of his art made his stay there a pleasant one and were the prelude to another period of intense creative activity. He painted the banks of the Oise, three large pictures with wide-spreading cornfields, the celebrated picture of the little Mairie at Auvers, with a palette determined by the atmosphere of the Ile-de-France. He also painted a portrait of Dr Gachet (Plate 46) and several others. This was the last impetuous effort of his life. 'I will give you back the money or give away my soul', he wrote to his brother.

On 27 July he borrowed a revolver on the pretext that he wanted to shoot crows, went into the fields, leaned against the trunk of a tree and shot himself in the stomach. 'Misery will never end', was one of the last things said to his brother.

Theo followed him to the grave six months later. They are buried side by side in the little churchyard of Auvers-sur-Oise.

Outline Biography

1853 Born on 30 March in Groot-Zundert, North Brabant, where his father was the Protestant pastor.

1857 Theo van Gogh, Vincent's brother, born 1 May.

1865 Sent to a boarding school in Zevenbergen.

1869 Through his uncle, an art dealer, obtains a post as a salesman in the Hague offices of Goupil and Co., a firm of art dealers and printsellers.

1873 Transferred to the newly opened London branch of Goupil and Co.

1874 In October is sent to Paris for a few months.

1875 Moves to Paris, to the head office of the firm. Sees a large exhibition of drawings and pastels by Millet.

1876 Dismissed from Goupil and Co. in March. Returns to England to teach in a school for poor children in Ramsgate, and afterwards becomes an assistant at a church school outside London. Goes up to London to see the galleries.

1877 Works from January to April in a bookshop in Dordrecht. In May goes to Amsterdam and enters the University to study theology.

1878 Finds academic studies in Greek and Hebrew too taxing and withdraws from the course. Moves to Brussels to train as an evangelist. In November is sent to the mining district of the Borinage in southern Belgium.

1879 Dismissed from his probationary post and refused a full appointment on grounds of inadequacy as a preacher.

1880 In the summer decides to become an artist and takes up drawing with his brother's financial assistance. Studies the work of Millet, Daubigny and Rousseau by making copies. In October moves to the art centre of Brussels and meets Anthon van Rappard, a young Dutch artist.

1881 In April returns to Etten in Brabant and makes drawings of local peasants. In August visits The Hague and makes contact with artists living there, especially a cousin, Anton Mauve. In December leaves home and settles in The Hague, working initially under Mauve's supervision.

1883 In September leaves The Hague and moves to the northern province of Drenthe, a popular place with artists of the Hague School. Takes up painting seriously. In December goes to the new family home in Nuenen, Brabant.

1885 Paints *The Potato-Eaters* as a culmination of his studies of the local agricultural workers and weavers. In November moves to Antwerp.

1886 In March travels to Paris, where he lives with his brother. Enters the studio of Fernand Cormon. In the autumn meets John Russell, who introduces him to Impressionist techniques. Later meets other French painters – Signac, Bernard and Gauguin.

1888 Visits the studio of Seurat shortly before leaving Paris for Arles, in Provence. Gauguin comes to stay from October to December.

1889 In May enters the sanatorium of St-Paul-de-Mausole at St Rémy as a third-class voluntary patient. Continues to paint and is visited by Signac.

1890 In January an article on his work by Albert Aurier is published in the *Mercure de France*. Exhibits at the Belgian exhibition of *Les Vingt*, where he sells *The Red Vineyard* to Anna Boch. In May moves to Auvers, visiting Paris on the way. On 27 July shoots himself in the stomach. Dies 29 July.

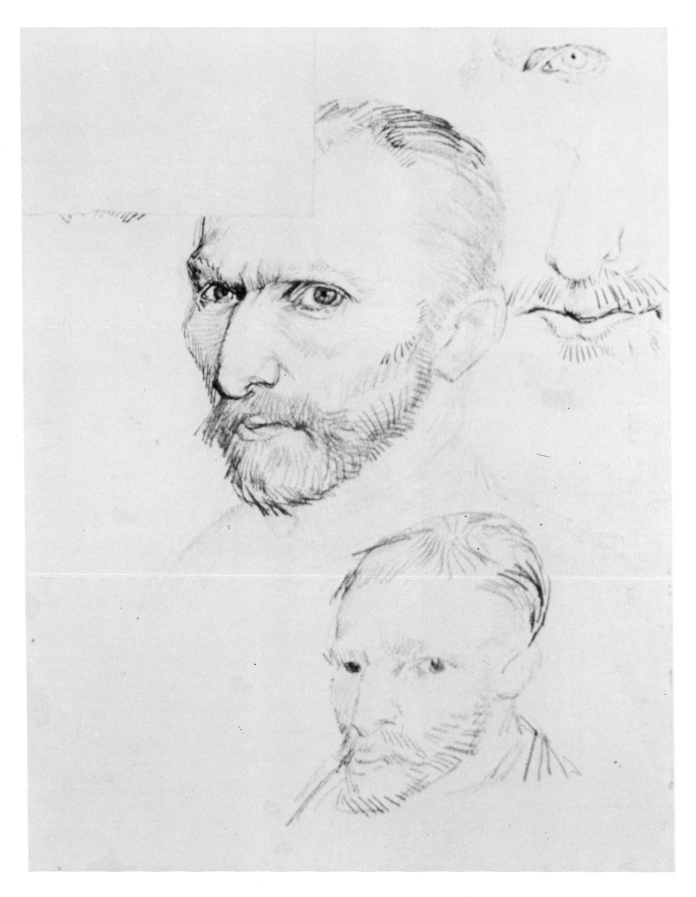

Fig. 15
Two Self-Portraits and Several Details
Pencil and pen and ink on paper, 31.6 x 24.1 cm. 1887.
Amsterdam, Rijksmuseum Vincent van Gogh

Select Bibliography

J. B. de la Faille, *The Works of Vincent van Gogh*, Amsterdam, 1970

C. Chetham, *The Role of Vincent van Gogh's Copies in the Development of his Art*, New York, 1976

L. Gans et al., *Vincent van Gogh: Catalogue of the Collection in the Rijksmuseum Kroeller-Muller*, Otterlo, 1970

V. van Gogh, *Verzamelde Brieven*, Amsterdam, 1974

V. van Gogh, *Complete Letters*, London and New York, 1959

A. M. Hammacher, *Van Gogh: A Documentary Biography*, London, 1982

S. Loevgren, *The Genesis of Modernism*, Bloomington, 1971

H. Marius, *Dutch Painting in the Nineteenth Century*, London, 1973

C. Nordenfalk, 'Van Gogh and Literature', *Journal of the Warburg and Courtauld Institutes*, 1947: Vol. 10

F. Orton, 'Van Gogh's Interest in Japanese Prints', *Vincent*, 1971, Vol. 1:3

D. Outhwaite, *Van Gogh's Auvers Period*, London University M.A. Thesis, 1969

R. Pickvance, *English Influences on Van Gogh*, London, 1974

R. Pickvance, *Van Gogh in Arles*, New York, 1984

R. Pickvance, *Van Gogh in Saint-Rémy and Auvers*, New York, 1986

G. Pollock, *Van Gogh and the Hague School*, London University M.A. Thesis, 1972

G. Pollock and F. Orton, *Vincent van Gogh*, London, 1978

G. Pollock, *Van Gogh's Dutch Years*, Amsterdam, 1980

J. Rewald, *Post-Impressionism from Van Gogh to Gauguin*, New York, 1956

M. Roskill, *Van Gogh, Gauguin and the Impressionist Circle*, London, 1970

M. Roskill, 'Van Gogh's "Blue Cart" and his Creative Process', *Oud Holand*, 1966, Vol. 81:1

M. Schapiro, *Van Gogh*, New York, 1950

L. van Tilborgh and J. van der Wolk (eds), *Vincent van Gogh: Paintings and Drawings*, Otterlo and Amsterdam, 1990

B. Welsh Ovcharov, *Van Gogh In Perspective*, Englewood Cliffs, 1974

B. Welsh Ovcharov, *Vincent van Gogh: His Paris Period, 1886-1888*, Utrecht, 1976

List of Illustrations

Colour Plates

Text Figures

Comparative Figures

16. Two Women Digging
Oil on canvas. October 1883. Amsterdam, Rijksmuseum Vincent van Gogh

17. Peasant Woman Gleaning
Black chalk on paper. August 1885. Essen, Folkwang Museum

18. Woman Resting her Head in her Hands
Pen, pencil, sepia and wash on paper. April 1882. Otterlo, Rijksmuseum Kröller-Müller

19. View of the Boulevard de Clichy (detail)
Oil on canvas. Late 1886 or spring 1887. Amsterdam, Rijksmuseum Vincent van Gogh

20. Suburbs of Paris: La Barrière
Watercolour on paper. 1887. Amsterdam, Rijksmuseum Vincent van Gogh

21. Arles seen from the Wheatfields
Pen and ink on paper. Summer 1888. Private collection

22. Jacob Maris: The Drawbridge
Watercolour on paper. 1875. Amsterdam, Rijksmuseum

23. Claude Monet: Boats at Etretat
Oil on canvas. 1884. New York, Mr and Mrs John Hay Whitney

24. Paul Gauguin: Self-Portrait
Oil on canvas. September 1888. Amsterdam, Rijksmuseum Vincent van Gogh

25. The Artist's Bedroom
Sketch from letter 554, 17 October 1888. Amsterdam, Rijksmuseum Vincent van Gogh

26. Harvest at La Crau ('The Blue Cart')
Watercolour and ink on paper. June 1888. Cambridge, Massachusetts, courtesy of the Fogg Art Museum, Harvard University, bequest Grenville L. Winthrop

27. Haystacks
Reed pen and ink on paper. June 1888. Budapest, Museum of Fine Art

28. The Reaper (detail)
Oil on canvas. July 1889. Amsterdam, Rijksmuseum Vincent van Gogh

29. Portrait of Madame Ginoux, after a drawing by Paul Gauguin
Oil on canvas. January-February 1890. Otterlo, Rijksmuseum Kröller-Müller

30. Sketch from Letter 592
May 1889. Amsterdam, Rijksmuseum Vincent van Gogh

31. Armand Roulin
Oil on canvas. November 1888. Essen, Folkwang Museum

32. Olive Groves in the Alpilles
Pencil, reed pen and ink on paper. 1889. East Berlin, Nationalgalerie

33. Sketch of a Perspective Frame from Letter 223
1882. Amsterdam, Rijksmuseum Vincent van Gogh

34. Peasants at a Meal
Black chalk on paper. April 1890. Amsterdam, Rijksmuseum Vincent van Gogh

35. Rembrandt van Rijn: The Raising of Lazarus
Etching. About 1632. Reproduced by courtesy of the Trustees of the British Museum, London

36. Marguerite Gachet at the Piano
Oil on canvas. June 1890. Basle, Kunstmuseum

37. Plain at Auvers
Oil on canvas. June 1890. Vienna, Kunsthistorisches Museum

Farmhouses

Oil on canvas on pasteboard, 36 x 55.5 cm. September 1883. Amsterdam, Rijksmuseum Vincent van Gogh

Fig. 16
Two Women Digging

Oil on canvas,
27 x 35.5 cm.
October 1883. Amsterdam,
Rijksmuseum Vincent van
Gogh

Van Gogh decided to become a professional artist in the summer of 1880; but it was not until the autumn of 1883 that he seriously took up oil painting. He had been experimenting with oil during his stay in The Hague, whose modern urban life he had tried to depict, but not to his satisfaction. In September 1883 he moved out of the city to the northern province of Drenthe, where he painted this study of moss-covered thatched farm buildings. The move to Drenthe marked Van Gogh's decision to take rural life and labour as the subject of his art. Both of these required a new style of work, facilitated by oil paint. Van Gogh's initial investigations of landscape painting were awkward; small and tentative in scale, painted thickly in deep tones. Most of the paintings are, with few exceptions (Fig. 16), empty of the people who worked and shaped the landscape. Space is minimal and there is little sense of distance. The viewpoint is low and close, and the resultant paintings do not convey the spaciousness of the Drenthe landscape which Van Gogh so often described in his letters to his brother.

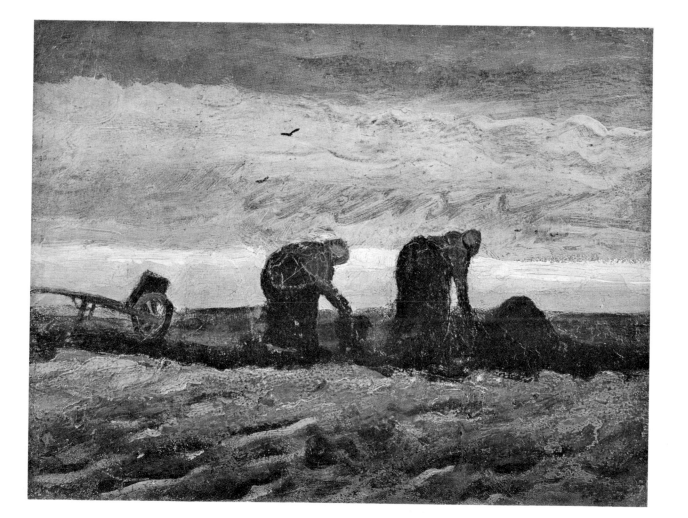

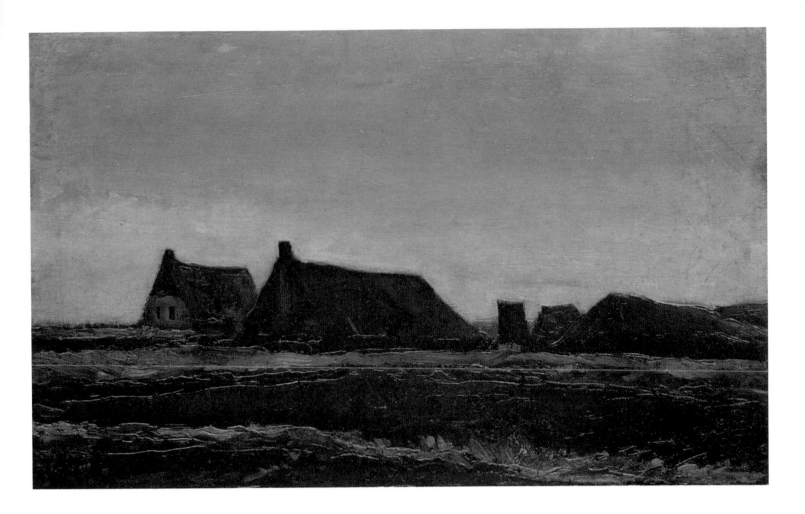

Sheaves of Wheat

Oil on canvas, 40 x 30 cm. August 1885. Otterlo, Rijksmuseum Kröller-Müller

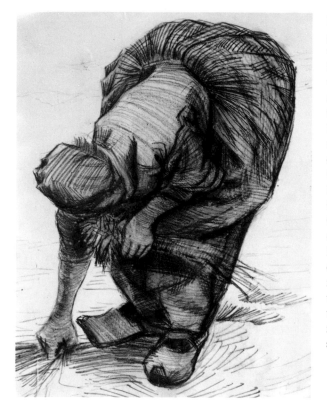

Fig. 17
Peasant Woman
Gleaning

Black chalk on paper, 51.5
x 41.5 cm. August 1885.
Essen, Folkwang Museum

In December 1883 Van Gogh moved back to the region in which he had grown up, Brabant. His aims as an artist, initially evolved in Drenthe, were to be realized in Brabant, in the 'heart of rural life'. He would become a painter of peasants, in the footsteps of Jean François Millet, who was for Van Gogh *the* peasant painter and the founder of modern art. In Nuenen Van Gogh was able to paint and draw more from the figure; the rural labourers of Brabant were often unemployed and, because they needed money, they agreed to pose for the painter. The most important work of this period in Nuenen was a multi-figure composition of peasants at home eating their meal – *The Potato-Eaters* (1885; Otterlo, Rijksmuseum Kröller-Müller). The picture was harshly criticized. Van Rappard, friend and fellow artist, questioned Van Gogh's right to claim comparison with Millet. To answer this, Van Gogh began a series of large drawings (Fig. 17) of men and women digging, cutting wood, gleaning – tasks which Millet had represented in his series of drawings, *Labours of the Fields*. Van Gogh also responded to the disappointment of his ambitions for *The Potato-Eaters* by returning to pure landscapes, but using a brighter and richer palette than he had been able to in Drenthe. This painting of a wheatsheaf is typical of these new colour studies. The centrality and scale of the motif, set against simple bands of varying yellow-golden tones, presents the wheatsheaf almost as a surrogate figure.

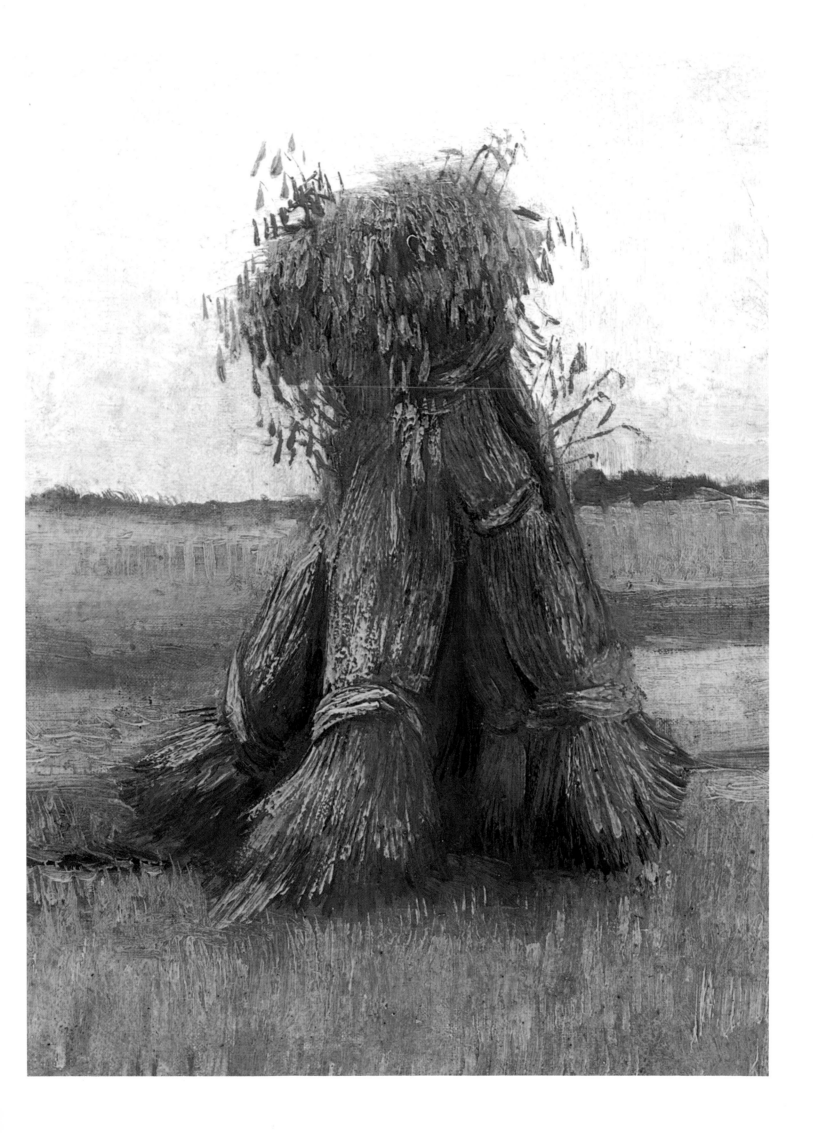

Portrait of a Woman in Profile

Oil on canvas, 60 x 50 cm. December 1885. New York, private collection

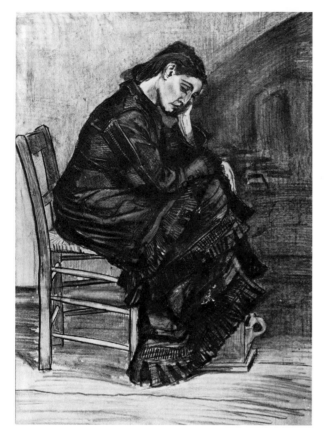

Fig. 18
**Woman Resting
her Head in her
Hands**

Pen, pencil, sepia and
wash on paper, 58 x 42 cm.
April 1882. Otterlo,
Rijksmuseum Kröller-
Müller

Conscious of his failure in the field of rural genre, Van Gogh decided to return to the city. He planned to go to Paris in the hope that the new movements in Parisian painting, of which he had heard from his brother, might provide him with new directions for his work. To prepare himself for this encounter with Paris and its urban population and motifs Van Gogh went to the Belgian port of Antwerp. Some important changes took place in the three months he spent there. He visited the museums and carefully studied the portraiture and colourist palette of Frans Hals, and in a series of experimental portraits, of which this is one, he tried to apply the animated brushwork and juxtaposed colours he had noticed in Hals's painting. Apart from a few sketches of Antwerp's landmarks and scenes in and around the cafés of the port, Van Gogh concentrated on painting portraits. But they were not commissioned portraits: that market was, as he noted, being served by the photographic studios. The model for this portrait was a woman from a *café-concert*, a motif associated with modern city life. But Van Gogh has not painted this woman, this social type, in her social setting, or in any context at all. Nor is she presented in an expressive, narrative or sentimental pose as was often the case in Van Gogh's earlier images of women from his Hague period, when he used the prostitute Clasina Hoornik as his model (Fig. 18).

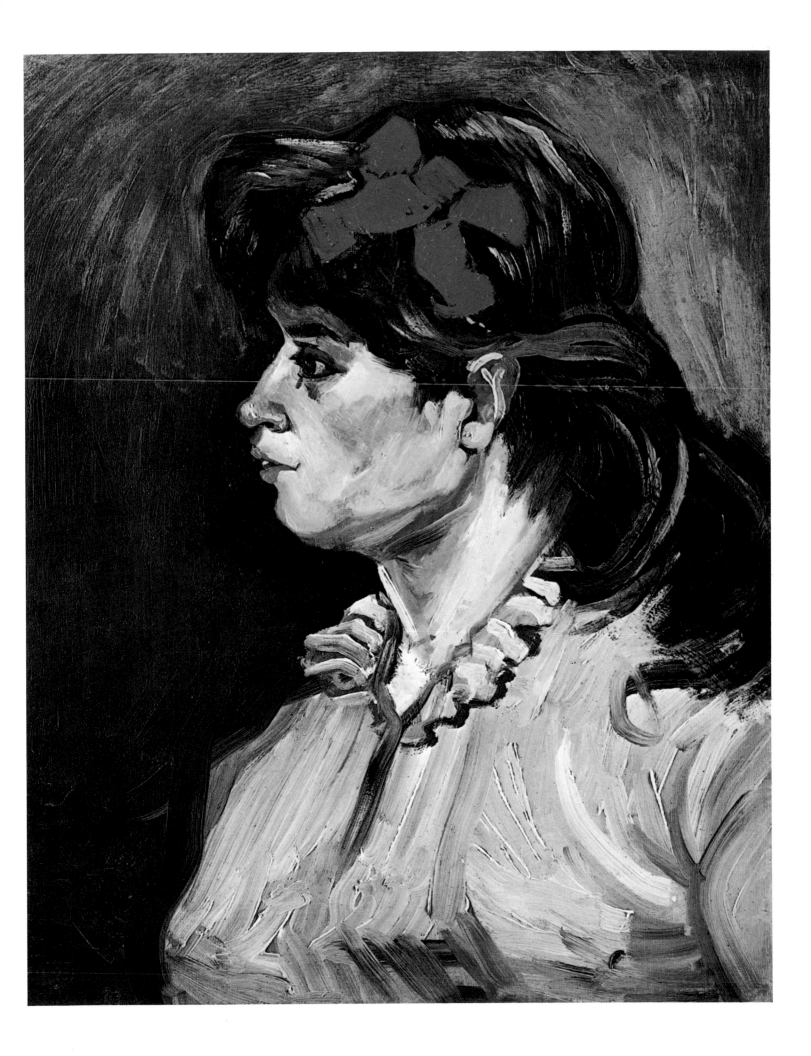

4 Flowers (Fritillaries) in a Copper Vase

Oil on canvas, 73.5 x 60.5 cm. Spring or summer 1887. Paris, Musée D'Orsay

Van Gogh arrived in Paris in March 1886. Although he was able to see a considerable amount of contemporary French painting by the Impressionists and their followers – Seurat's *Sunday Afternoon on the Island of the Grande Jatte* (1886; Chicago, Art Institute) was exhibited twice in 1886 – he took little notice for at least a year. As a letter written to an English artist he had met in Antwerp reveals, he continued with what he had been doing in Antwerp. He enrolled again in an atelier, where he could draw and paint the nude from plaster casts and live models. Since he could ill afford to hire models, he painted large numbers of still lifes of flowers in order to study the colour theory of Hals and Delacroix. He wrote that he was 'trying to render intense colour and not a grey harmony'. This painting indicates to what extent he had accomplished this aim. It also demonstrates the now varied ways in which he applied his paint: dashes in the background to break up the blue field of the wall, directional brushstrokes on the table, impasto highlights on the metal vase. The plant itself is virtually drawn in colour; each leaf is a separate stroke and the heads of the flowers are depicted with more voluptuous and solid sweeps of paint.

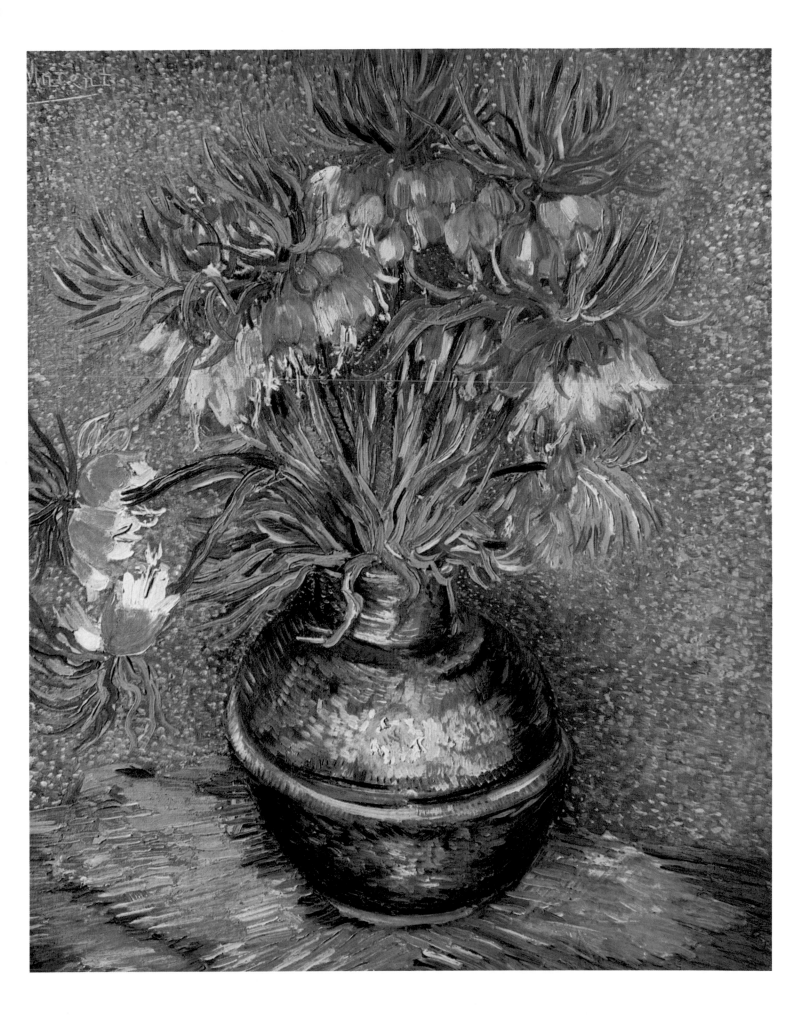

5 Cornfield with a Lark

Oil on canvas, 54 x 64.5 cm. Summer 1887. Amsterdam, Rijksmuseum
Vincent van Gogh

In his letter to Levens, the English painter, Van Gogh did mention one of
the Impressionists – Claude Monet, the landscape painter. In the autumn
of 1886 Van Gogh met an Australian painter, John Russell, who had just
spent the summer painting with Monet in Brittany. It was probably Russell
who first explained Monet's work and the principles of Impressionist paint-
ing to Van Gogh. In the following months he explored these novel insights
and made the acquaintance of other artists of the Parisian vanguard. Yet
when one examines this landscape, painted in the summer of 1887, these
encounters seem to have had little impact. Admittedly the palette is dif-
ferent from those of the Drenthe and Nuenen periods, and the paint is
applied in small strokes and not broad, undifferentiated bands. But in com-
positional structure the painting is typical of Van Gogh's previous land-
scapes, especially of Drenthe. The viewpoint is low and intimate. The
canvas is crudely divided into three horizontal bands, grass in the fore-
ground, then the corn, and, above rather than beyond, an expanse of blue
sky which does not achieve any of the atmospheric or luminous subtlety of
Impressionist painting. The sky is not the source of light, and thus the
colour in the painting, however much it is richer and brighter in tone than
before, does not represent the fall and diffusion of sunlight. Moreover each
object, each blade of grass and stem of corn, is carefully delineated. Forms
are not dissolved into colour and light. The cornfield is not a mere 'appear-
ance', but is almost physical in its tactility.

Self-Portrait with Grey Felt Hat

Oil on canvas, 44 x 37.5 cm. 1887. Amsterdam, Rijksmuseum Vincent van Gogh

42

Van Gogh often used himself as a model for practising figure painting. His Paris self-portraits serve as a useful record of his painterly experiments. This one of autumn 1887 has often been discussed as evidence of the impact of Neo-Impressionism upon Van Gogh. (Artists such as Seurat and Signac developed a method whereby paint was applied systematically in small adjacent dots; the technique was known as pointillism or division-ism.) But this cannot be the case. There is no systematic use of a single, unifying method of paint application in this self-portrait. The use of scattered dots of colour in the background and the overall reduction of the size of the brushmarks are symptomatic of a different strategy. Van Gogh has employed a distinct kind of mark for each area of the canvas. These diverse and almost graphic systems of marks are related to the object or texture being represented. In the treatment of the face and head, the brushstrokes are directional, following and thus describing the planes and shapes in order to convey the structure and volume of the head or the texture and growth pattern of the facial hair. In addition the portrait informs us about Van Gogh in Paris. The image he presents by portraying himself in smart suit and hat is of Van Gogh as a man of the city.

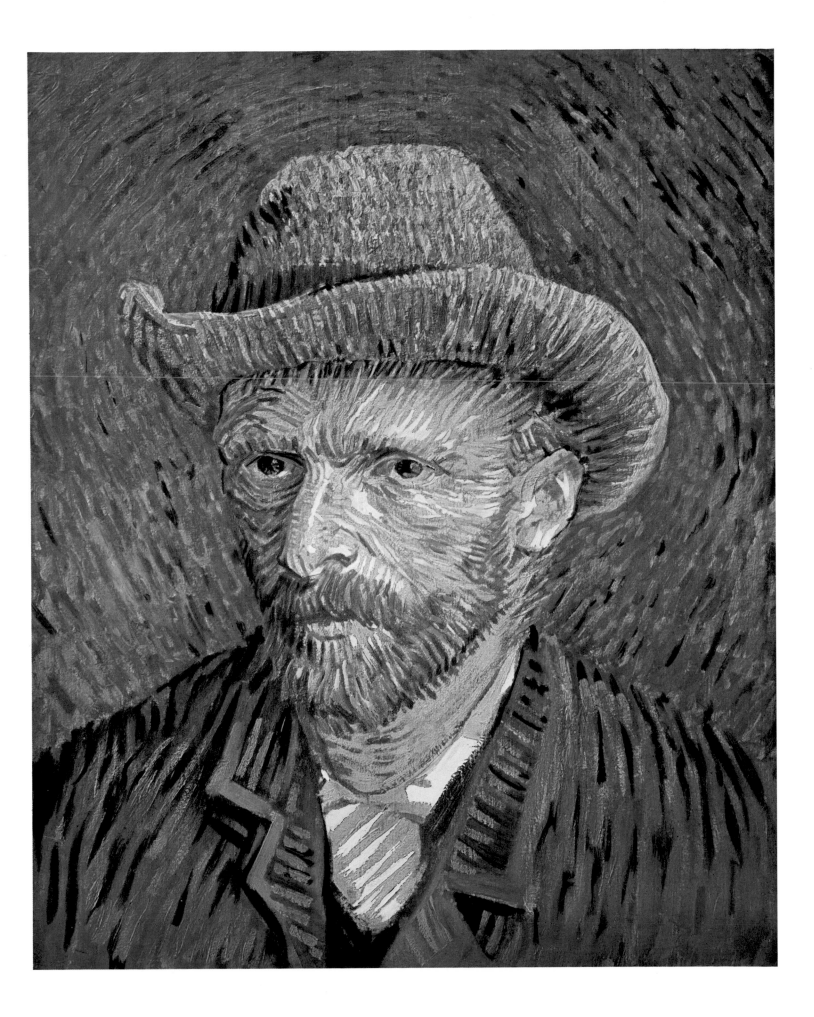

Portrait of Julien (Père) Tanguy

Oil on canvas, 92 x 75 cm. Late 1887. Paris, Musée Rodin

The sitter in this portrait was the colour-merchant Tanguy, a Breton peasant who had settled in Paris and ran a small paint shop in the Rue Clauzel, much frequented by vanguard artists. His shop had become a kind of gallery of their paintings, for Tanguy would take paintings on deposit as credit for the painting materials he supplied. Van Gogh painted two portraits of 'Père' Tanguy in the autumn and early winter of 1887, both against a background composed of Japanese colour woodcuts which he had begun to collect, firstly in Antwerp and then more avidly in Paris. Tanguy is placed massively in the centre of the canvas, facing the spectator. But the Paris merchant is presented not against an urban or even French setting, but in an imaginary context composed of Japanese seasonal scenes and costumed figures. Although this choice of background indicates Van Gogh's evident preoccupation with Japanese prints – he also made individual copies of selected prints at this date – the painting does not indicate any profound influence of Japanese graphic styles or perspectival devices upon his work. But it is important to note that the motifs represented in the prints anticipate those that Van Gogh would shortly resume when he left Paris and moved once again into a more rural setting – seasonal landscapes and portraits of regional types in costume.

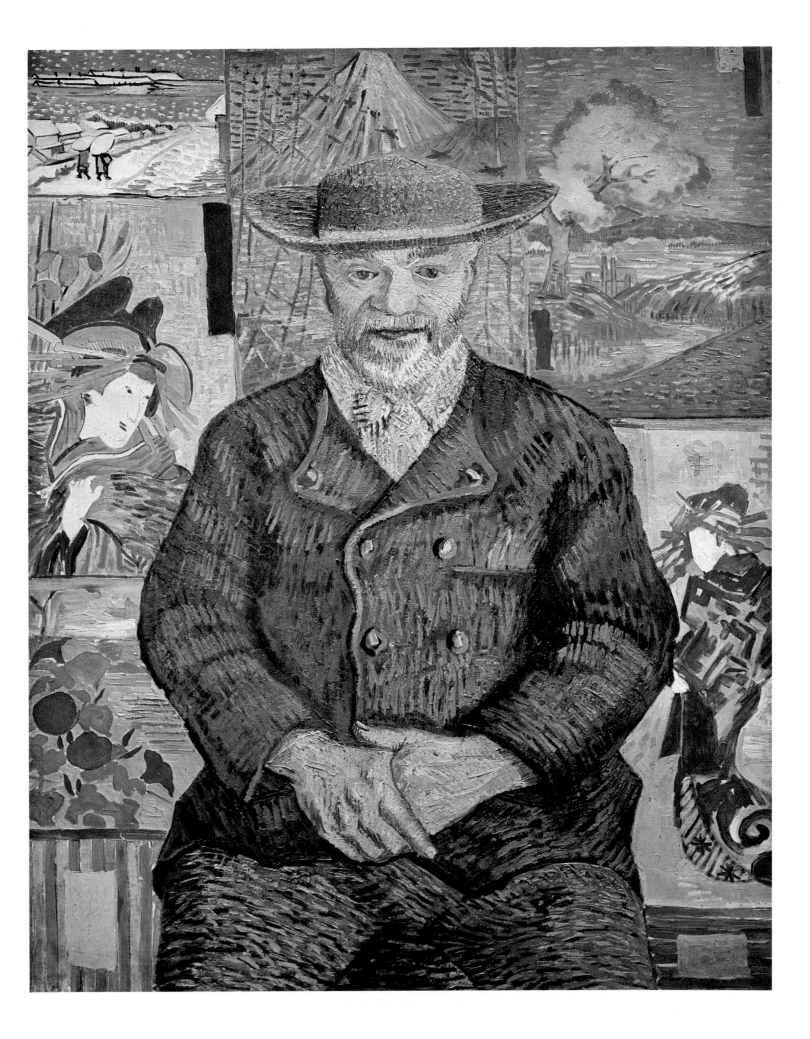

Self-Portrait in front of an Easel

Oil on canvas, 65 x 50.5 cm. January 1888. Amsterdam, Rijksmuseum Vincent van Gogh

8

Shortly before he left Paris and moved to Provence in late February 1888, Van Gogh painted this final self-portrait. He is no longer dressed as the urban dandy, but in the blue blouson of the Parisian working class. He stands before his easel, holding his palette in a pose intentionally reminiscent of a self-portrait by Rembrandt which was then in the Louvre and well known to Van Gogh. Perhaps the painting should be read as a kind of manifesto of the new orientation in his conception of himself as an artist and of his work – the intention to remove himself from the city and its bourgeois lifestyle, and the desire to be seen in a Dutch rather than a French tradition. The painting also betrays a growing confidence in himself as an artist: he appears with the insignia of his profession. Greater assurance is also evident in the handling. The extreme experimentation with pure or broken colour and a textured and structuring brushwork in the earlier self-portrait (Plate 6) has given way to a more controlled and coherent treatment. On the other hand it is less tight than the Tanguy portrait (Plate 7). In the pose he has used, Van Gogh evokes Rembrandt; but the painterly treatment and coloration remind us of another seventeenth-century Dutch artist – Frans Hals. The lessons Van Gogh had learnt in Antwerp, explored in greater depth throughout the Paris period, are now successfully integrated into his work to produce a distinctive style.

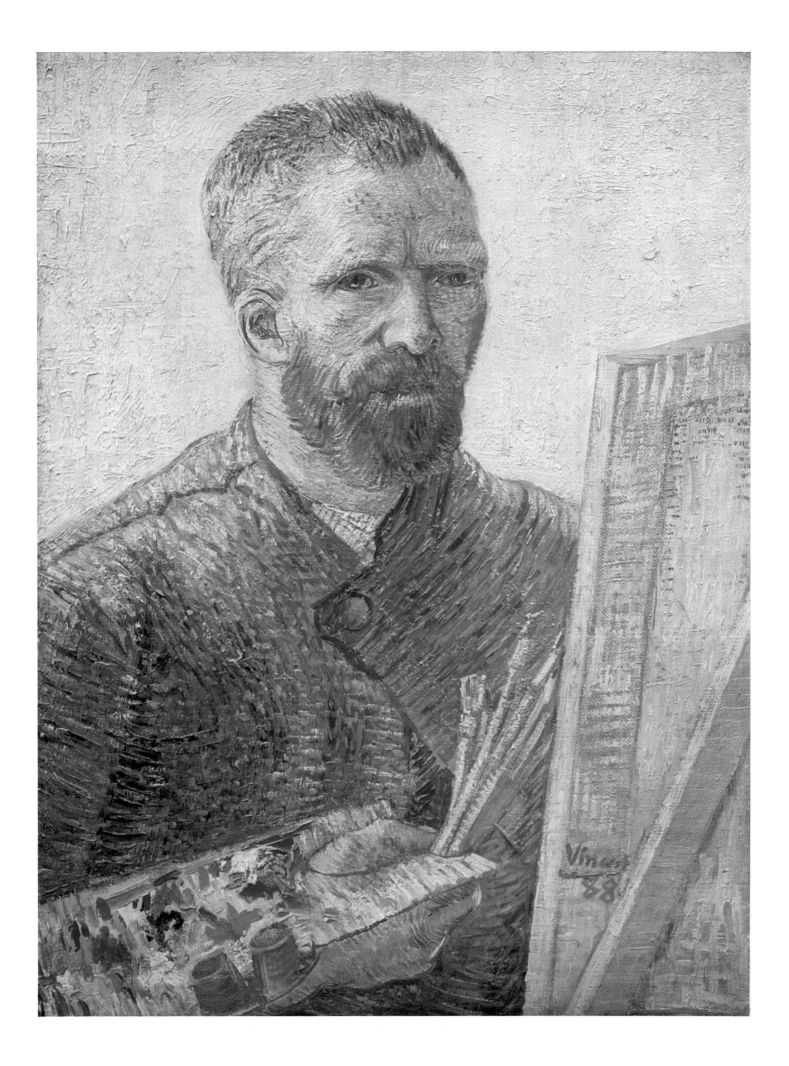

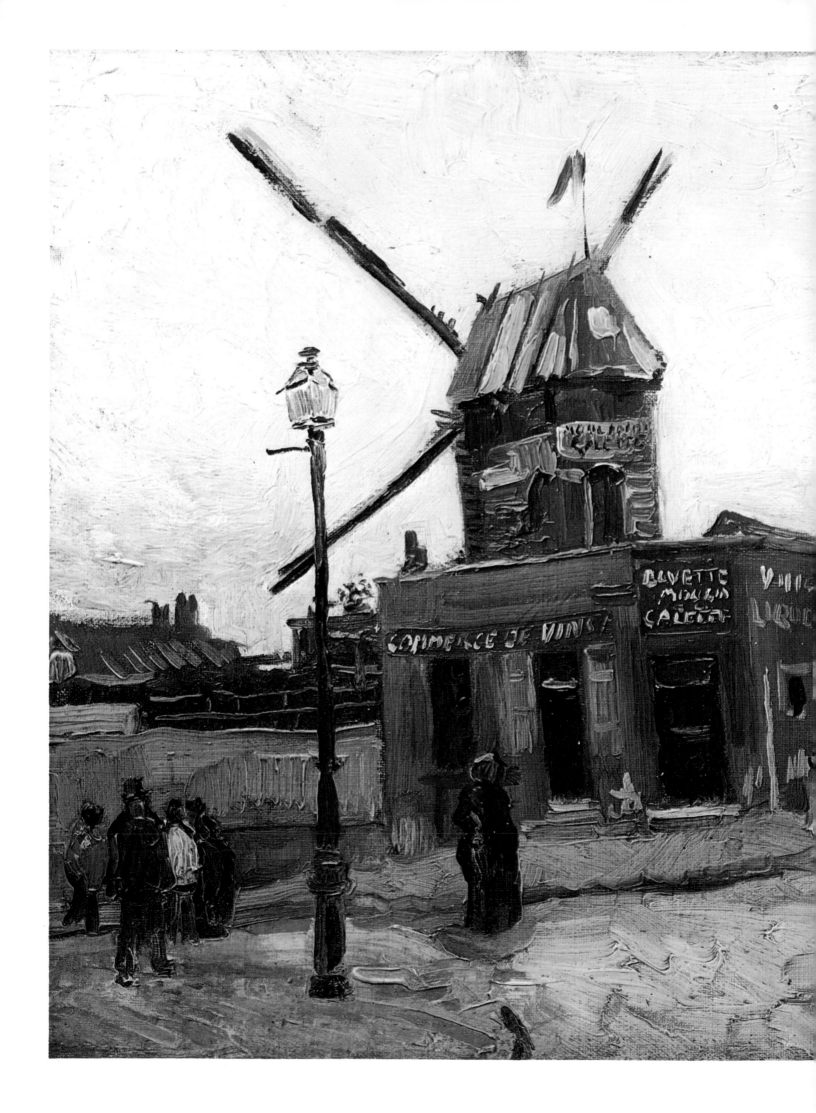

Oil on canvas, 38.5 x46 cm. Spring 1886. Otterlo, Rijksmuseum
Kröller-Müller

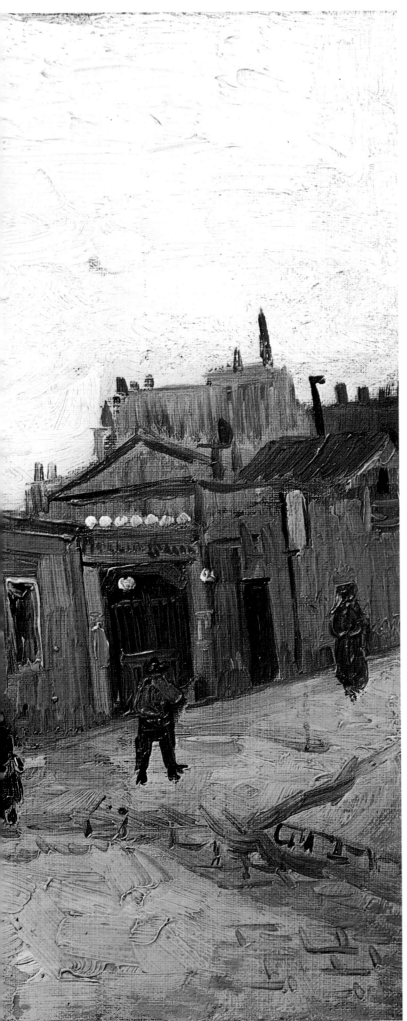

The preceding selection of paintings from the Paris period
provides a rough map of Van Gogh's artistic concerns and
stylistic experiments over the years he spent in the French
capital. The following three plates raise different issues,
about how he engaged with Paris as subject-matter.
During his sojourn in The Hague he had tried to represent
a modern city as it changed and expanded. His attention
was focused on the uneven edges where town and country
met, often awkwardly: straggling housing developments,
iron-rolling mills in meadows beside windmills, new
streets, as yet unbuilt, marked out by lamp-posts. In Paris
Van Gogh explored similar aspects of that phenomenon,
and in doing so he shared the concerns of the first
generation of Impressionists. But they had portrayed the
leisure-places in the fast-growing suburbs as well as Paris
itself – Montmartre for instance. Van Gogh lived in
Montmartre, just below the famous Moulin de la Galette
(then a dance-hall), and this detail of one of his initial
paintings of the mill shows the urban face of Montmartre.
He also painted a Montmartre that was still rural, the place
of stone quarries, market gardens and windmills. The
broad handling and dull palette are reminiscent of his
Nuenen work (Plate 2). The figures are just silhouettes
composed of slicks of paint. None the less, one can still
glean from this abbreviated figure notation the mixed
social composition of the Montmartre street scene – a
bourgeois, a workman, some fashionably dressed ladies.

The Restaurant de la Sirène at Asnières

Oil on canvas, 57 x 68 cm. Summer 1887. Paris, Musée du Louvre

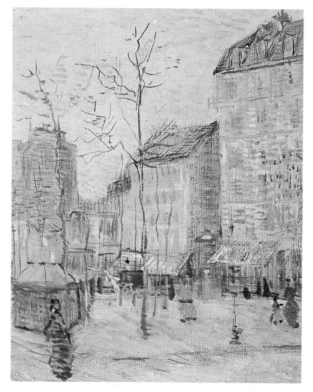

Fig. 19
View of the
Boulevard de
Clichy (detail)

Oil on canvas,
46.5 x 55 cm. Late 1886 or
spring 1887. Amsterdam,
Rijksmuseum Vincent van
Gogh

By the middle of 1887 a dramatic change of style has occured in Van Gogh's work. Using these characteristically 'impressionist' motifs of a restaurant on the outskirts of Paris and a street scene on the Boulevard de Clichy (Fig. 19), Van Gogh seems to have been willing to experiment with Impressionist techniques as well. However, both paintings lack a sense of substance and conviction, which reflects his difficulty in feeling himself as part of the world he is portraying. These two sites, Clichy and Asnières, represent a shift within the Paris vanguard in the 1880s. The Boulevard de Clichy, one of the new boulevards of Haussmann's Paris, belongs to the celebratory iconography of the Impressionists in the 1870s. Asnières, on the other hand, was a growing industrial suburb in which a new generation was working. There Signac painted gas-tanks, and Seurat the tattiness of the strolling crowds on a Sunday afternoon, promenading on an island in the Seine with factories in the distance. Already ambivalent about modern urban life, Van Gogh found it difficult to participate in these aspects of Paris. In the two years he spent there he tried to assimilate French Impressionism, only to find that a new generation of painters were questioning its premises regarding both subject-matter and style. His flirtation with Impressionist subject-matter was brief; encounters with the Neo-Impressionists led him to believe that Paris could no longer be the subject of modern French painting.

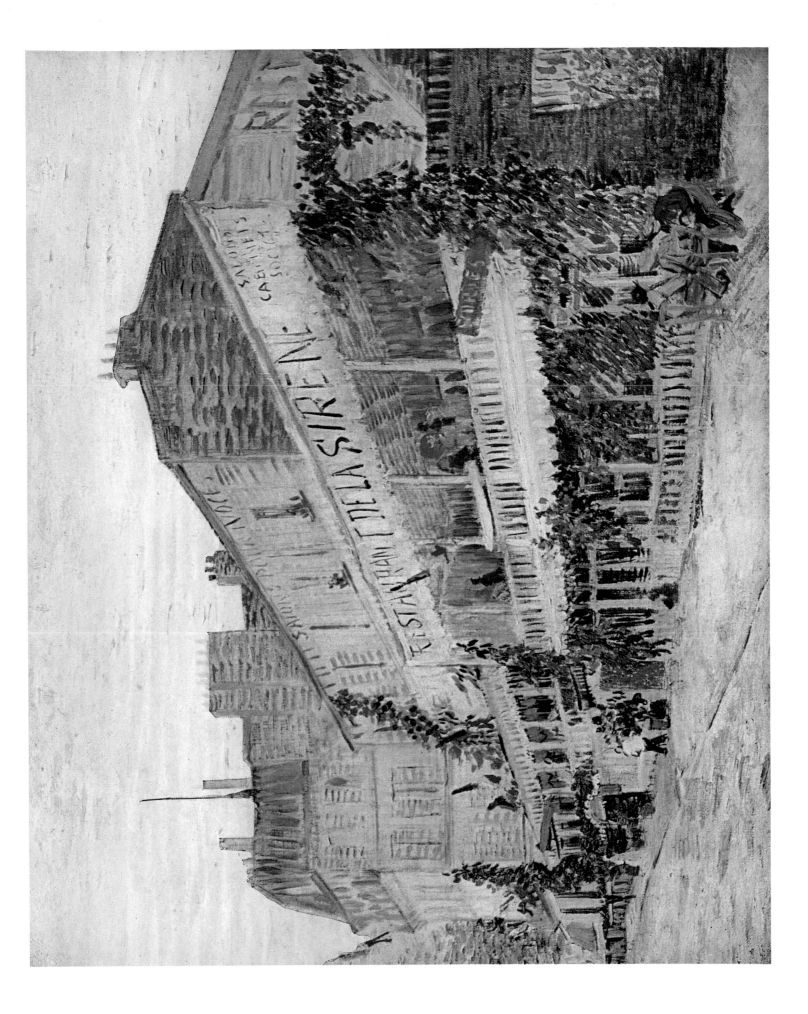

Watercolour on paper, 39.5 x 53.5 cm. Summer 1887. Amsterdam, Stedelijk Museum

This picture offers a very different view of Paris from that of Plate 10. It is painted in watercolour, with solid areas of colour and controlled graphic strokes. This is Paris seen at the edges, this time not from within looking out, but from outside. We see Paris across a frontier marked by a path which also represents the meeting of town and country. The 'country' fills almost half the picture, but this enlarged foreground, closest to us, is virtually empty except for a roofless cottage, some quarried stones, and some handcarts. The city, compressed into the middle ground, is dense, inhabited, busy. Factories smoke above and between packed houses and tenements. In the distance we see hills and another large stretch of countryside. This watercolour coincides chronologically with a series of depictions Van Gogh made of the edge of Paris, especially of the ramparts near La Barrière (Fig. 20), a part of Paris made famous by Victor Hugo's descriptions in *Les Misérables*. Here people stroll, brought out from the metropolis by horsedrawn trams. Again there is a considerable foreground, an expanse which distances Paris and its promenaders from the artist and the spectator. The space is awkward and the composition fragmented. By contrast, in the watercolour of Paris near Montmartre there is a clearer order, a sequence of planes viewed from above, composed coherently to distinguish town and country. The difficulties of the space and perspective of the Drenthe landscapes are seemingly overcome and the solution indicates a kind of rejection of Paris and its modes of painting. The picture demonstrates Van Gogh's conquest of the vocabulary of seventeenth-century Dutch landscape painting and its vision of the harmonious and hierarchical relations of town and country.

Fig. 20
Suburbs of Paris:
La Barrière

Watercolour on paper,
39.5 x 53.5 cm. 1887.
Amsterdam, Rijksmuseum
Vincent van Gogh

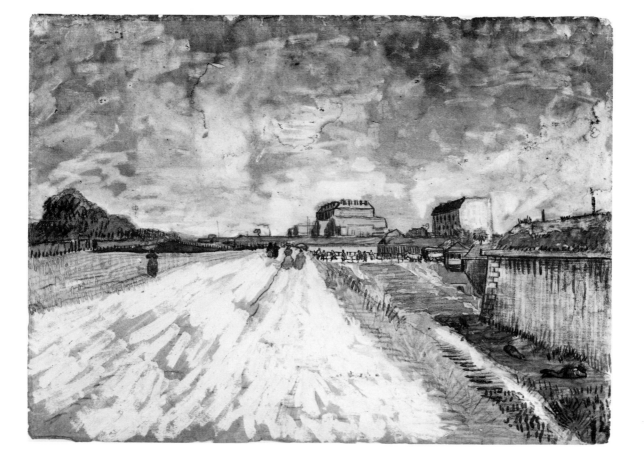

The Yellow House, Place Lamartine, Arles

Oil on canvas, 76 x 94 cm. September 1888. Amsterdam, Rijksmuseum Vincent van Gogh

Fig. 21
Arles seen from
the Wheatfields

Pen and ink on paper, 31.5
x 24 cm. Summer 1888.
Private collection

In late February 1888 Van Gogh left Paris. He moved to the Provençal town of Arles, where he remained for two years; it was a move from the city to a more rural environment, though Arles was a substantial, industrial town. But here, from his house on the place Lamartine, Van Gogh could easily walk out into wheatfields nearby. The Yellow House on the square near the railway station on the outskirts of Arles was Van Gogh's home and studio and he proudly painted this portrait of it in September 1888. More than one art historian has drawn attention to the relation between Van Gogh's 'townscape' and the tradition of seventeenth-century Dutch townscape painting. The flux and flurry of Paris, which Van Gogh found so difficult to capture in the painting of the boulevard de Clichy (Fig. 19), are absent. Forms are solidly painted and the figures are fixed. The effect created is one of a comfortable and friendly locale. In the accompanying drawing (Fig. 21) Arles is presented from another angle, from outside in the wheatfield where the workers are harvesting. Rural labour carries on beneath the towers and factories of Arles. A train steams by. Town and country are juxtaposed harmoniously. The formula for this representation of their relationship was provided by another seventeenth-century Dutch tradition, exemplified by Ruysdael's numerous paintings of Haarlem seen across the fields. Van Gogh borrowed this formula – produced in another age and another country, and representing another economy and its social relations – in order to resolve fictively the contradictions of town and country which he witnessed in his own period. Within this ordered vision he can accommodate signs of that modern industrial society – the train and the factory.

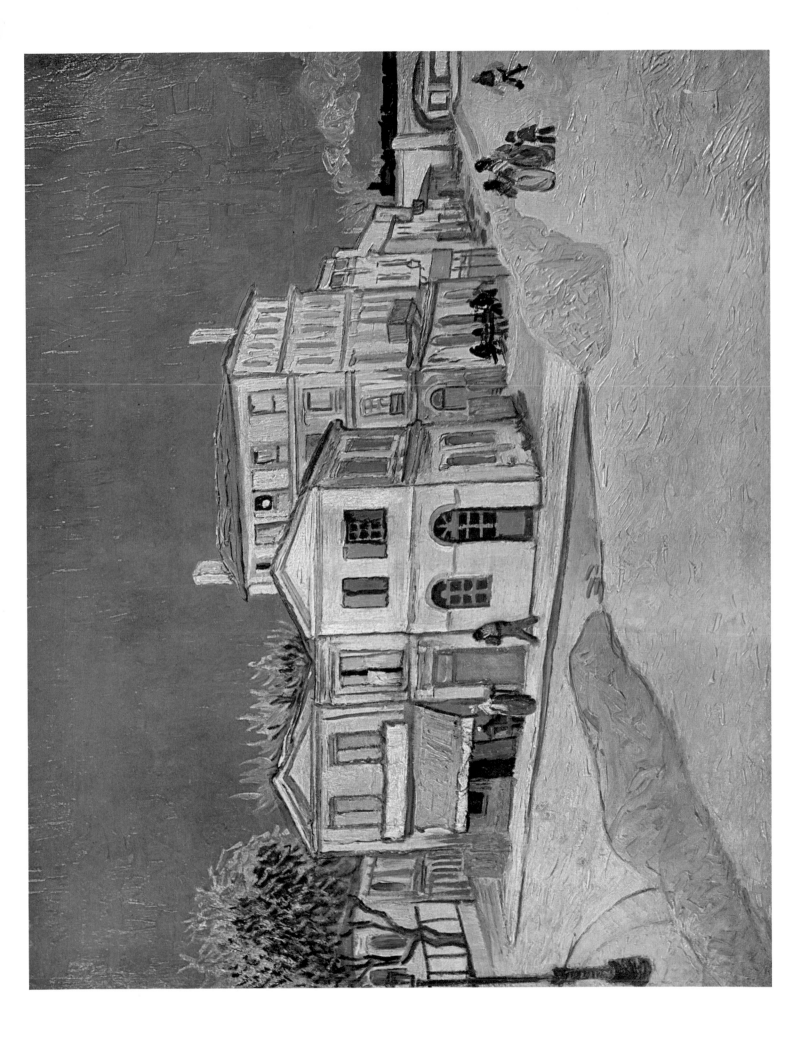

13 The Drawbridge near Arles

Watercolour on paper, 30 x 30 cm. March 1888. Private collection

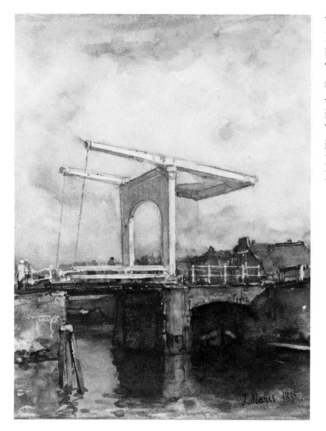

Fig. 22
Jacob Maris: The
Drawbridge

Watercolour on paper,
28.3 x 21.6 cm. 1875.
Amsterdam, Rijksmuseum

Van Gogh made many drawings and paintings of this bridge, the Pont Langlois outside Arles. Here laundresses are washing in the river beneath it. In other treatments lovers stroll along the bank towards it. This drawbridge gives further evidence of the ways in which Van Gogh recomposed Arles and its environs in the image of another time and place – in Holland. The drawbridge is closely associated with Dutch landscape; it signifies 'Dutchness'. Moreover it was a common motif in the work of Van Gogh's Dutch contemporaries of the Hague School, as for instance in this watercolour by Jacob Maris of 1875 (Fig. 22). But the Pont Langlois was Dutch in another, more literal way: it was in fact built by Dutch engineers.

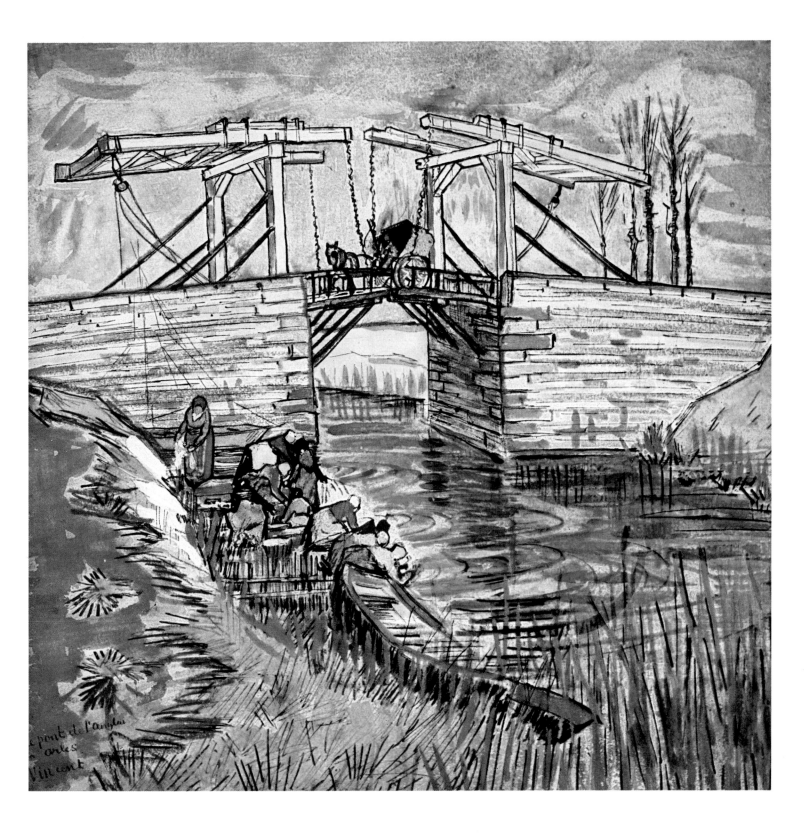

The Café Terrace at Arles at Night

Oil on canvas, 81 x 65.5 cm. September 1888. Otterlo, Rijksmuseum Kröller-Müller

In a letter to his sister Wilhelmina of September 1888 Van Gogh described two paintings he had just done of cafés at night. One was a working-class café, where 'poor night wanderers sleep'; the other was a fashionable café in the Place du Forum in the town centre, painted under a brilliant starry sky. The former was painted in virulent reds and greens, clashing yellows and oranges; in the latter Van Gogh has used intense and cheerful yellows and blues. He referred his sister to a novel by Guy de Maupassant, *Bel Ami,* in which he had found a description of a starlit night in Paris with the brightly lit cafés of the boulevards. This was 'approximately the same subject' as he had just painted. Although Van Gogh did not name a literary parallel for his other, less salubrious and more proletarian night café, it is probable that the imagery of Emile Zola's novel *L'Assommoir,* suggested the subject. *Assommoir* is the French word for night café, and Zola's novel plots the road to dissolution through drink of the laundress heroine in one of these all-night haunts. These paintings indicate that Van Gogh was indeed responsive to the urban subject-matter of modern Parisian artists, but equally that he found it more accessible through the narratives of Naturalist novelists. Their literature embodied for him the achievement which modern painting needed to emulate. Where, he once asked, was the Guy de Maupassant of modern figure painting?

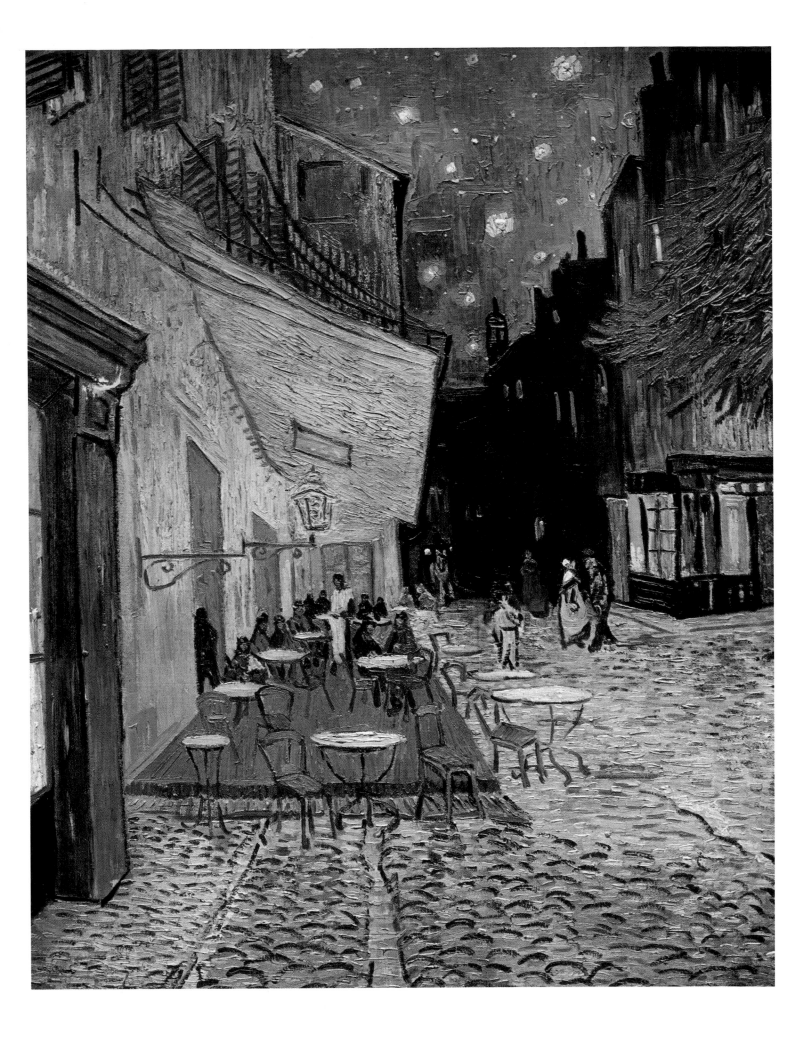

The Artist on the Road to Tarascon

Oil on canvas, 48 x 44 cm. August 1888. Destroyed in the Second World War

Other aspects of Provence had more direct literary connotations. Tarascon, a small town about ten miles north of Arles, was associated with the French novelist Alphonse Daudet, notably through his book about a Provençal lionhunter, *Tartarin de Tarascon*. Van Gogh praised this novel in a letter to his brother for being 'so fine in colour'. Later, in the autumn of 1888, he painted some old stagecoaches in Tarascon which were mentioned in the novel; Daudet makes them deplore modern progress and in particular the railway that has displaced them. This curious self-portrait of Van Gogh as artist, walking beside the cornfields to Tarascon, painted in rich colour which intensifies the sense of the South, may be full of implied references to Daudet. It is not only a memento of a walk to Daudet's town, but also a statement about Van Gogh and the South he had discovered through literature. A drawing of this same scene, but without the figure of the artist, was sent to the Australian artist Van Gogh had known in Paris, John Russell. Van Gogh has also presented himself here as the *plein-air* painter, wandering in search of motifs with his portable studio on his back.

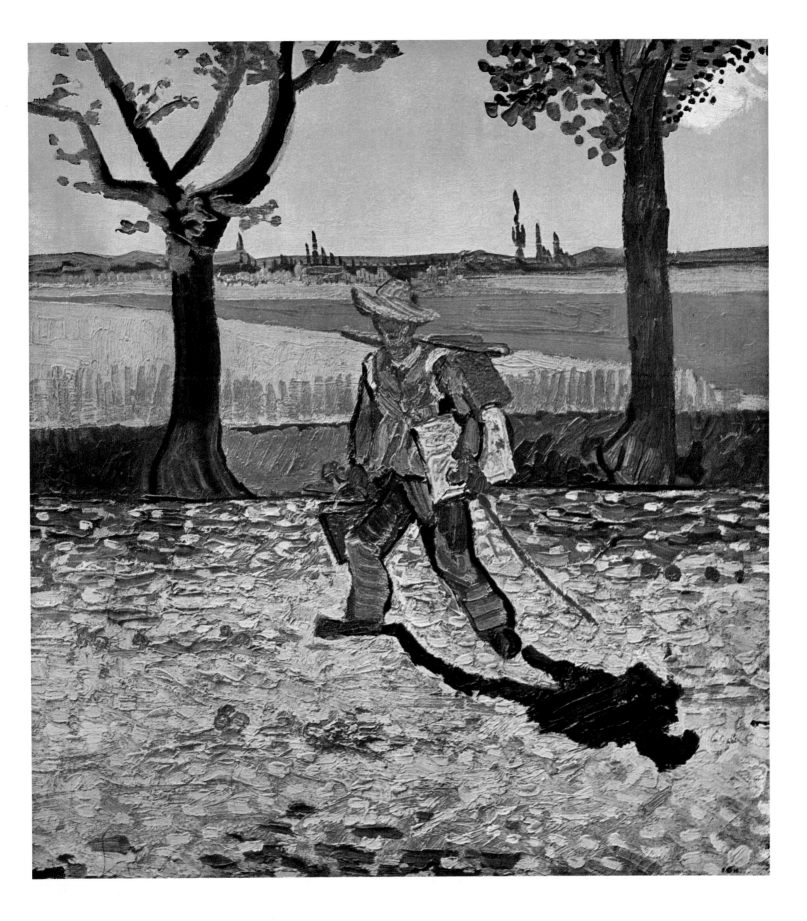

Boats at Les Saintes-Maries

Watercolour on paper, 39 x 54 cm. June 1888. Location unknown

In June 1888 Van Gogh travelled by coach across the Camargue, which reminded him of Holland, to the seaside resort of Les Saintes-Maries-de-la-Mer on the Mediterranean. The village was famous for its fortified cathedral, built like a ship, the curious design of the thatched roofs of its cottages, and its fishing fleet. Van Gogh recorded all of these. But the novel opportunities of the place were the sea and the colourful boats. In the years 1881-3 Van Gogh had often visited Scheveningen, a fishing village and holiday resort on the North Sea, a few miles from The Hague. There he drew the great fishing smacks drawn up on the beach, in the manner of Hague School painters such as Henrik Mesdag and Anton Mauve. Van Gogh's excursus into marine painting in June 1888 recalls their pictures and his own early essays in this genre. In a letter about this trip to the seaside he explicitly compares Les Saintes-Maries with Dutch seascape; it was different only in the greater brilliance of its colours. The motif of small boats drawn up on the beach also occurs in the work of Monet in the 1880s. In a letter of summer 1888 Van Gogh compares not his boat pictures but the painting of the Tarascon coaches to Monet's pictures of coloured boats on the beach (Fig. 23).

Fig. 23
**Claude Monet:
Boats at Etretat**

Oil on canvas,
72.9 x 92.8 cm.
1884. New York,
Mr and Mrs John Hay
Whitney

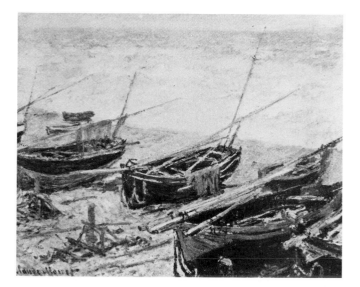

Unloading Sand

Oil on canvas, 55 x 65 cm. August 1888. Essen, Folkwang Museum

The town of Arles is on the Rhône, and that busy waterway appears in a number of Van Gogh's works. He painted the quayside with stevedores at work as well as more panoramic views of the river as it sweeps its way through the town. But in such works there is something stylized and remote about his treatment, as if it was difficult to come to terms with this aspect of Arles. There is a quality of ambivalence reminiscent of Monet's evasive treatment of signs of modern labour and industry on the banks of the Seine near Argenteuil. The painting is curious. The barges and their workmen are solidly and attentively painted; but the setting is minimal and unfinished. Nothing indicates exactly where this is all taking place. A small stretch of quayside suddenly gives way to a sketchy river bank, a beach even. Beside the barges a man in a rowing boat is fishing, but his relation in space and scale to the barges is not clear. Van Gogh sent the painting to his friend and fellow artist Emile Bernard. A dedication was painted on the canvas which has since been erased. In the accompanying letter Van Gogh admitted that the painting was only an attempt at a picture. But he stressed that although it was painted directly from the motif it was not in the least 'impressionist'. Perhaps he was intending to take on the older Impressionists like Monet on their own territory – using their subject-matter – and to transform it by a more solid handling and a greater solidity of form. But apart from the foreground this has hardly been accomplished.

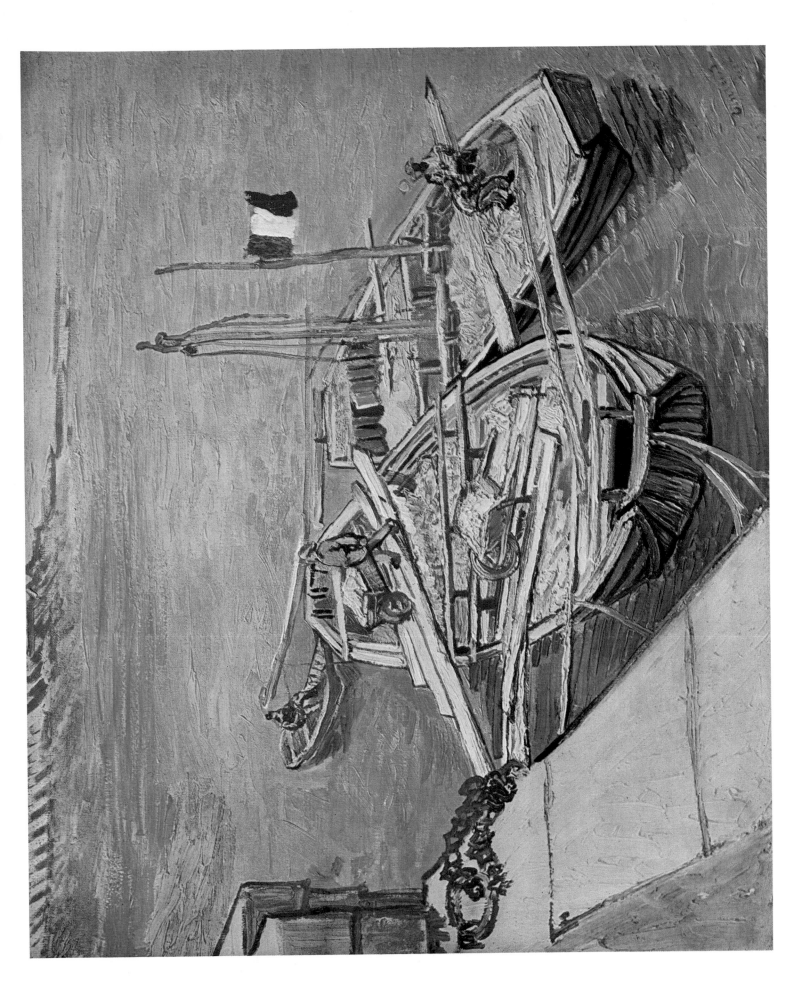

Gauguin's Chair

Oil on canvas, 90.5 x 72 cm. December 1888. Amsterdam,
Rijksmuseum Vincent van Gogh

In October 1888 Van Gogh realized a long-cherished plan to persuade
Paul Gauguin, whose acquaintance he had made in Paris, to come to
Arles, settle in the Yellow House, and found a Studio of the South.
Gauguin had been working in Brittany with Emile Bernard and several
other Parisian painters. Van Gogh had kept in close contact with this
group through his correspondence with Bernard and by exchanges of
work. He attempted to extend this system of exchanging information by
encouraging Gauguin and Bernard to paint portraits of each other to send
to him; he would paint a self-portrait for them. In the end Gauguin and
Bernard did the same and sent him self-portraits. All the paintings in this
project had the status of an artistic manifesto. Gauguin's, illustrated here
(Fig. 24), made a literary reference by incorporating the title of Victor
Hugo's novel *Les Misérables* and suggesting Gauguin's identification with
its hero, Jean Valjean. In early December 1888 Van Gogh began a pair of
pendant paintings of chairs, Gauguin's and his own (Plate 19). These pic-
tures are not just still lifes, however much the iconography is reminiscent
of the allegorical use of motifs in seventeenth-century Dutch still life.
The flame of a candle, for instance, is a commonplace in these, symboliz-
ing light and life. But these paintings are also oblique portraits. On
Gauguin's chair Van Gogh has placed two books, recognizable from the
colour of their covers as contemporary French novels. On his own chair
he has placed a pipe and a tobacco pouch, and in the background there
are sprouting onions. *Gauguin's Chair* is a night scene; his own, a daylight
scene.

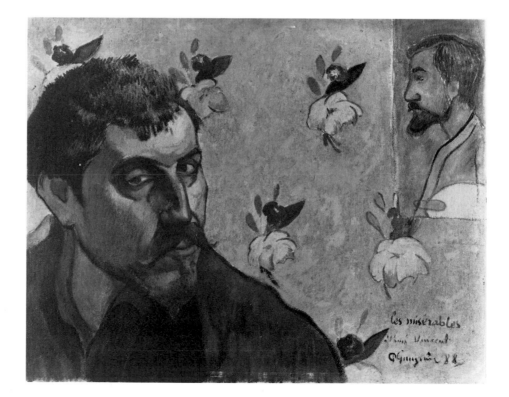

Fig. 24
Paul Gauguin:
Self-Portrait

Oil on canvas, 45 x 56 cm.
September 1888.
Amsterdam, Rijksmuseum
Vincent van Gogh

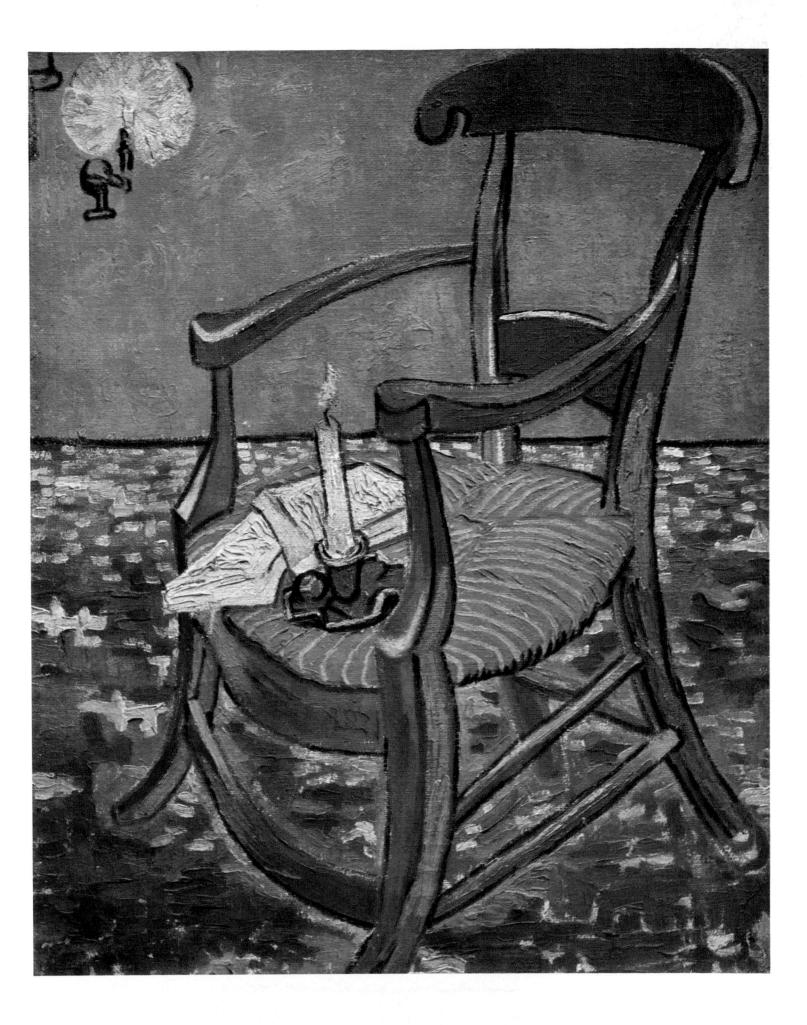

The Yellow Chair

Oil on canvas, 93 x 73.5 cm. December 1888 – January 1889. London, National Gallery

There is a further level of connotation in this pair of paintings. In 1883 Van Gogh told his brother of a story he had read about the English novelist Charles Dickens and the illustrator Luke Fildes. When Dickens died Fildes made a drawing which was reproduced in *The Graphic*, an illustrated periodical whose engravings Van Gogh collected. The drawing showed Dickens's workroom and now empty chair. Van Gogh explained to his brother what this image signified for him. He saw it as a symbol of the loss, through death, of the great pioneers of literature and graphic illustration. Moreover these men – especially the illustrators, who had created images to accompany and illustrate modern literature – had, so Van Gogh believed, worked in a collaborative and communal spirit. Their artistic community and shared endeavours provided Van Gogh with a model for his own dream of a new co-operative society of artists, based on the Studio of the South, which had been initiated by Gauguin's arrival in Arles.

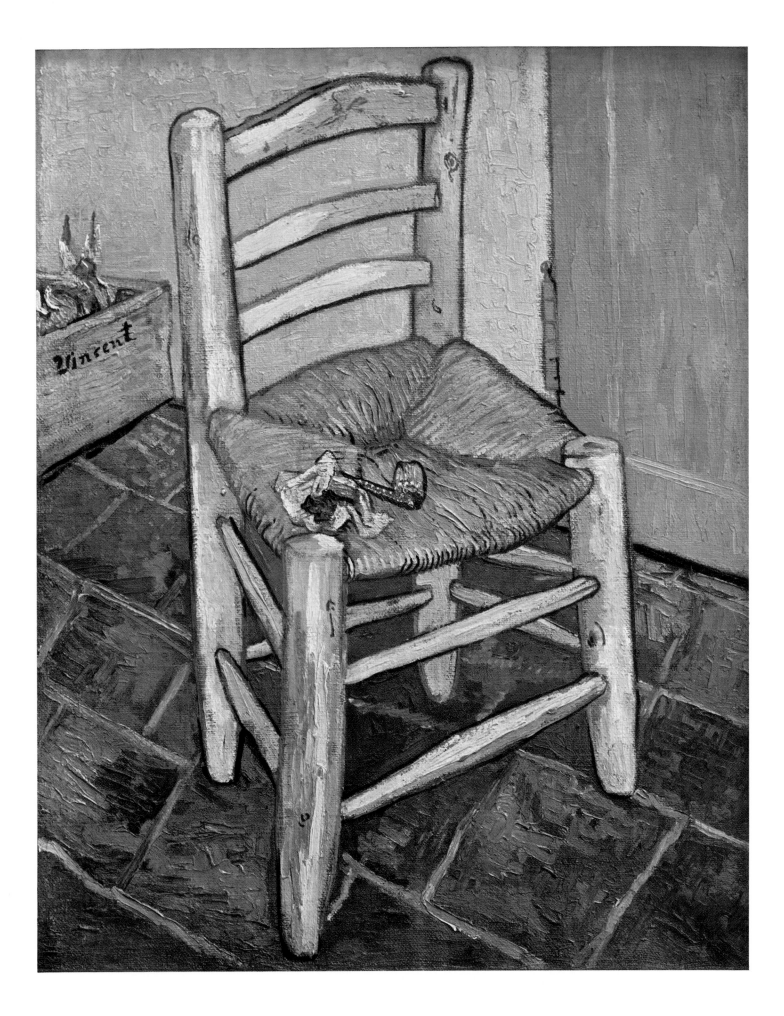

The Aliscamps at Arles

Oil on canvas, 73 x 92 cm. October 1888. Otterlo, Rijksmuseum Kröller-Müller

During his three-month stay in Arles Gauguin encouraged Van Gogh to abandon his predominantly Naturalist aesthetic principles, his need to paint directly from the motif. Gauguin argued that the artist should experiment more freely with the motif, using devices such as flattened areas of pure colour and a more decorative and abstracted line. He had brought with him examples of Emile Bernard's recent work in this direction. Van Gogh, desirous of keeping up with his fellow vanguardists, was at first willing to experiment along similar lines. In this painting of the Aliscamps at Arles, a long tree-lined pathway bordered by Roman sarcophagi, Van Gogh has adopted an oblique viewpoint which angles our vision down and across the promenade, excluding the sky and blocking any perspective into the distance. Trees, grass and pathway are painted in solid, heightened colours. The shapes are heavily and decoratively outlined. The scene is also a response to Bernard's work in another way. It is a scene of modern urban leisure. Here the bourgeois of Arles display themselves in a public promenade. Van Gogh knew Bernard's Seurat-like watercolour of a Sunday afternoon in a Breton meadow. He had noted of this work in a letter that it included two figures, ladies dressed in modern fashions and painted respectively in red and green. These figures and their colours made Bernard's otherwise regional genre scene 'a very modern thing'. In his own painting Van Gogh has included a fashionably dressed female figure in red. She stands in sharp colouristic opposition to the predominant green of the trees and the grass, and signals Van Gogh's ambition to make of his painting an equally 'modern' thing.

21 Still Life with Coffee Pot

Oil on canvas, 65 x 81 cm. May 1888. Paris, private collection

In his Dutch years Van Gogh had employed a tonal palette typical of the Barbizon painters and some of the Hague School artists. But in 1884-5 he encountered a new theory of colour in the books and articles he was reading about the French painter Delacroix. From these texts Van Gogh derived the thesis that one of the distinguishing features and great discoveries of recent art that made it 'modern' was the use of complementary and contrasting colours in place of tonality and chiaroscuro. The basic message of his reading was that each primary colour – red, blue, yellow – has a complementary colour composed of a mixture of the other two. The complement of red is green; of blue, orange; of yellow, violet. Shadows cast by an object should include the complementary colour of the object. Complementaries are also used to heighten and intensify the brilliance of colour. In his ambition to be modern Van Gogh adopted these theories, but without a sophisticated understanding of them or a sound technical foundation as a painter. He applied them crudely and programmatically, though often with unexpectedly powerful and original effects. During the spring and summer of 1888 Van Gogh corresponded regularly with Bernard, giving his friend reports on work in progress and describing his colour experiments such as this still life. The complementary pairs of blue and orange, yellow and violet can be easily recognized in this painting, and from the colour notes added to a sketch of it included in a letter to Bernard it is clear that the red-green pair was also employed. The background, which in reproduction appears yellow, was in fact a greenish tone. Around the picture Van Gogh has painted a red border, which serves to heighten and emphasize that green. The practice of painting a border of complementary colour onto the canvas was initiated by Seurat, who also employed modern colour theory.

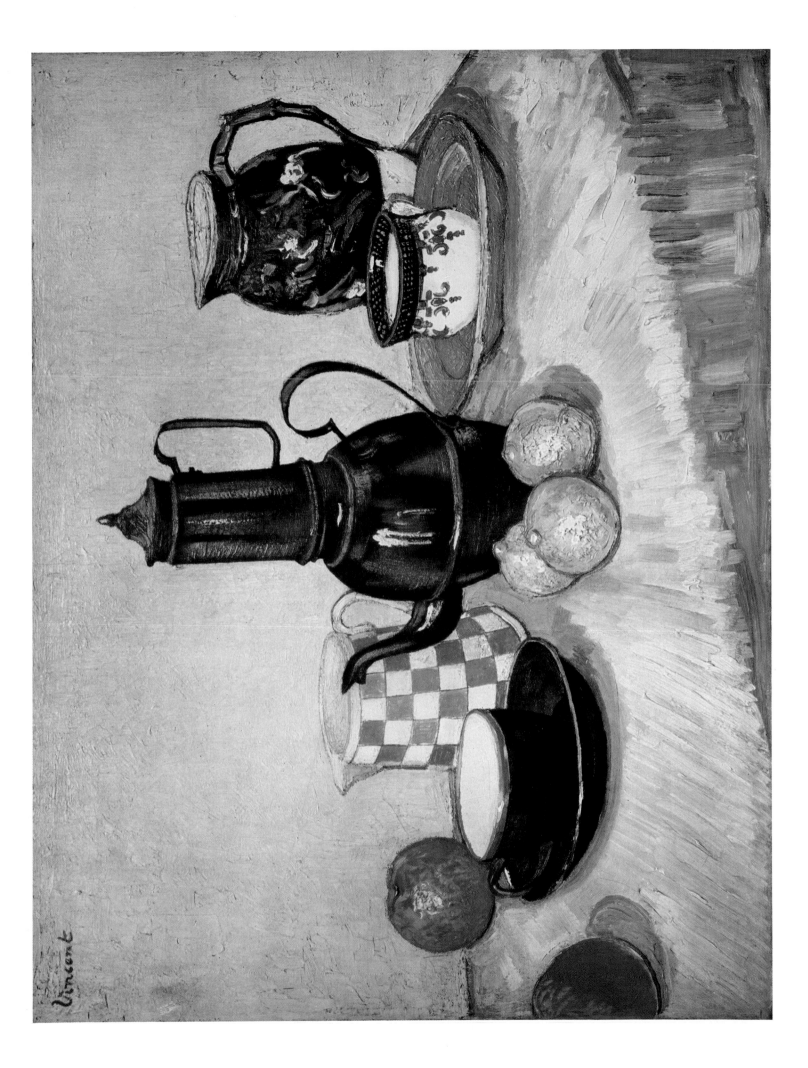

Still Life: Sunflowers

Oil on canvas, 93 x 73 cm. August 1888. London, National Gallery

Van Gogh prepared for Gauguin's visit to Arles by painting a series of canvases to decorate the Yellow House. Out of this project came a sequence of paintings of sunflowers. They are important as a series, and are more than just interior decoration. Firstly, in these paintings Van Gogh demonstrated a further aspect of his current studies of colour. They are painted mainly in variations on a single colour: yellow. However, instead of using violet, yellow's complementary, for contrast, he has introduced blue. Rigorous application of theory broke down in the face of a preference for this theoretically arbitrary combination. Its appeal lay in the fact that it had been used by a seventeenth-century Dutch artist much on Van Gogh's mind in Arles, Vermeer. Repeatedly Van Gogh associated Vermeer with yellow and blue, drawing Bernard's attention in his letters to a portrait by Vermeer in the Rijksmuseum in Amsterdam in which this combination was most brilliantly and subtly employed. Second, the idea of a series of interrelated canvases indicates a significant shift in Van Gogh's work away from a traditional conception of a painting as a single complex statement. His attempt to produce such a work in *The Potato-Eaters* had failed to convey his dense message. Instead Van Gogh explored the possibility of combining sequences of paintings, each having the status of a single word, into a kind of pictorial sentence. Later, in 1889, he suggested that the *Sunflower* canvases should be hung like the wings of a triptych to flank a portrait (Plate 34) and thus underline and elaborate the meanings of the portrait which it alone might not convey (Fig. 30).

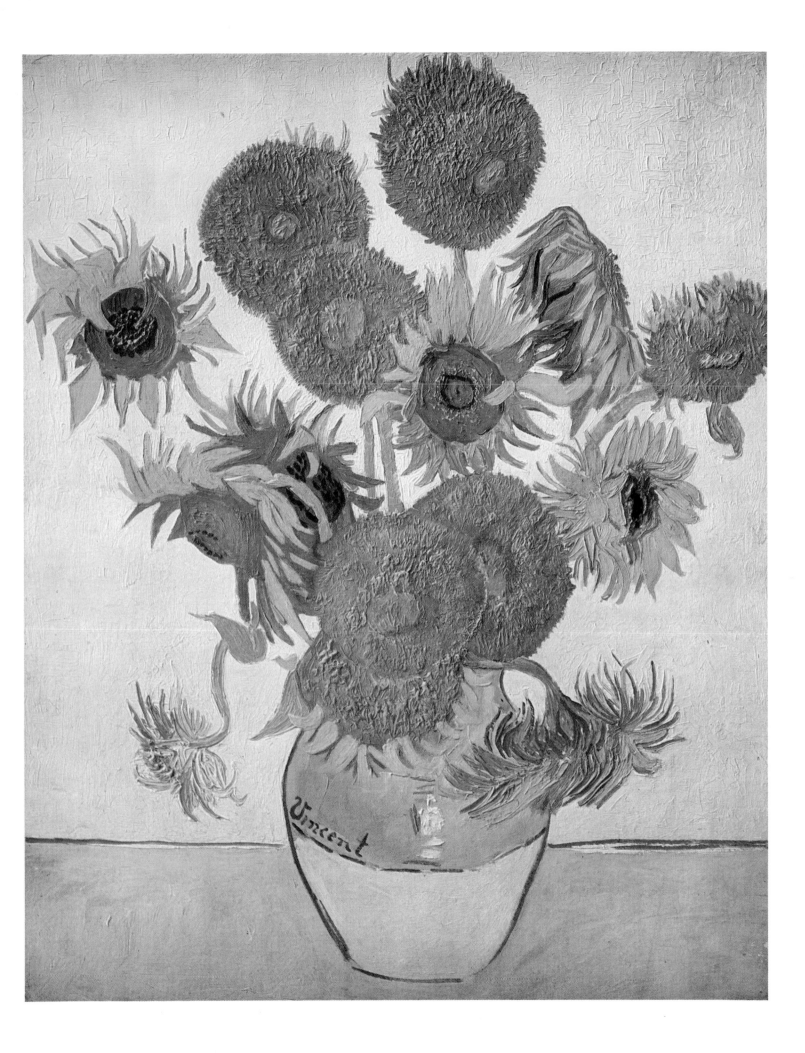

The Artist's Bedroom

Oil on canvas 72 x 90 cm. October 1888. Amsterdam, Rijksmuseum Vincent van Gogh

Van Gogh also painted a portrait of his bedroom in the Yellow House as part of the projected decoration of the house with works which would show Gauguin what he had been doing. He described the painting to his brother: 'This time it is simply my bedroom, only here colour is to do everything and, in giving by its simplification a grander style to things, to be suggestive of rest, or of sleep in general. In a word, looking at the picture ought to rest the brain, or rather the imagination.' This explanation to Theo was accompanied by a sketch (Fig. 25). One immediate difference between the painting and the sketch is colour. Van Gogh provided detailed colour notes in the letter containing the sketch. But more remarkable is the difference in the treatment of space in the two pictures, and the powerful effects of immediacy and invitation achieved in the painting precisely by the deviation from rigorous geometric perspective. The spatial effect of the relationship between the objects in the painting and the position in which we as spectators are placed has been perceptively described as 'phenomenological space', that is, spatial relations as we experience and remember them rather than as they are conventionally represented in paintings made according to the geometric perspective systems used by artists since the Renaissance. Thus, in addition to exploiting the expressive possibilities of colour, Van Gogh was investigating the expressive possibilities of new representations of space.

Fig. 25
The Artist's
Bedroom

Sketch from letter 554.
17 October 1888.
Amsterdam, Rijksmuseum
Vincent van Gogh

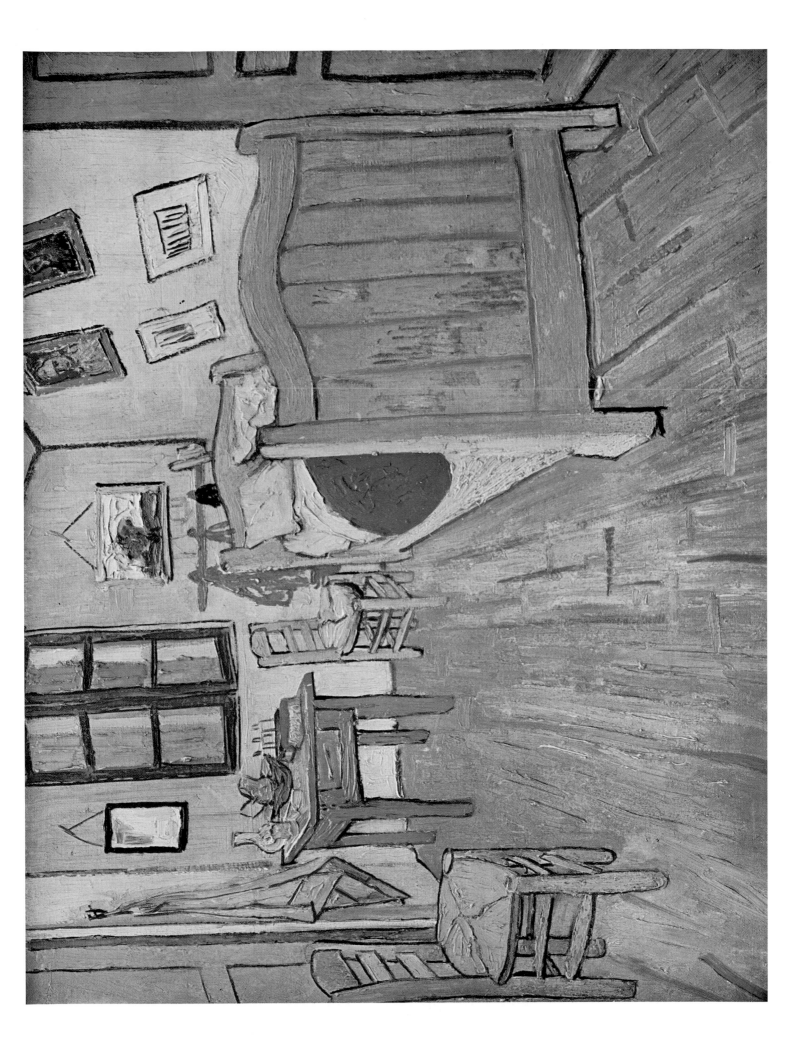

Harvest at La Crau ('The Blue Cart')

Oil on canvas, 72.5 x 92 cm. June 1888. Amsterdam, Rijksmuseum Vincent van Gogh

Van Gogh's production in Arles fell into a number of series, one of which comprised landscape paintings on the theme of the seasons. The original idea for a seasonal series, in which each season would be represented by a pair of complementary colours, had been put forward in Nuenen in 1884. On arrival in Arles in March 1888 Van Gogh began to paint a series of canvases of blossoming orchards in pinks and greens entitled *Spring*. In June he painted *Summer* in blue and orange, represented by the harvest on the plain of La Crau, which lay between Arles and the ruined monastery of Montmajour. This was an important work for Van Gogh; he made two preliminary drawings of the motif (Fig. 26) and when the painting was finished he made two further drawings after it. One of these was sent to John Russell. A comparison of the study and the completed painting reveals a number of important changes which were made in the process of production. In the painting, the space has been expanded. The viewpoint is higher and thus the great plain is laid out beneath us, receding more gradually to the distant towers of Montmajour and the hills beyond. Van Gogh often described the plain of La Crau in his letters, saying that apart from differences of colour it reminded him constantly of Holland, but not of modern Holland. In this landscape he saw the landscape paintings of the seventeenth-century artists Ruysdael and De Koninck, who were both famous for their panoramic landscapes. Van Gogh's paintings of the seasons in Provence are often an imaginary transposition to an earlier epoch in old Holland, and also to an almost timeless place where seasons come and go and nothing changes.

Fig. 26
Harvest at La Crau
('The Blue Cart')

Watercolour and ink on paper, 39.5 x 52.2 cm. June 1888. Cambridge, Massachusetts, courtesy of the Fogg Art Museum, Harvard University, bequest Grenville L. Winthrop

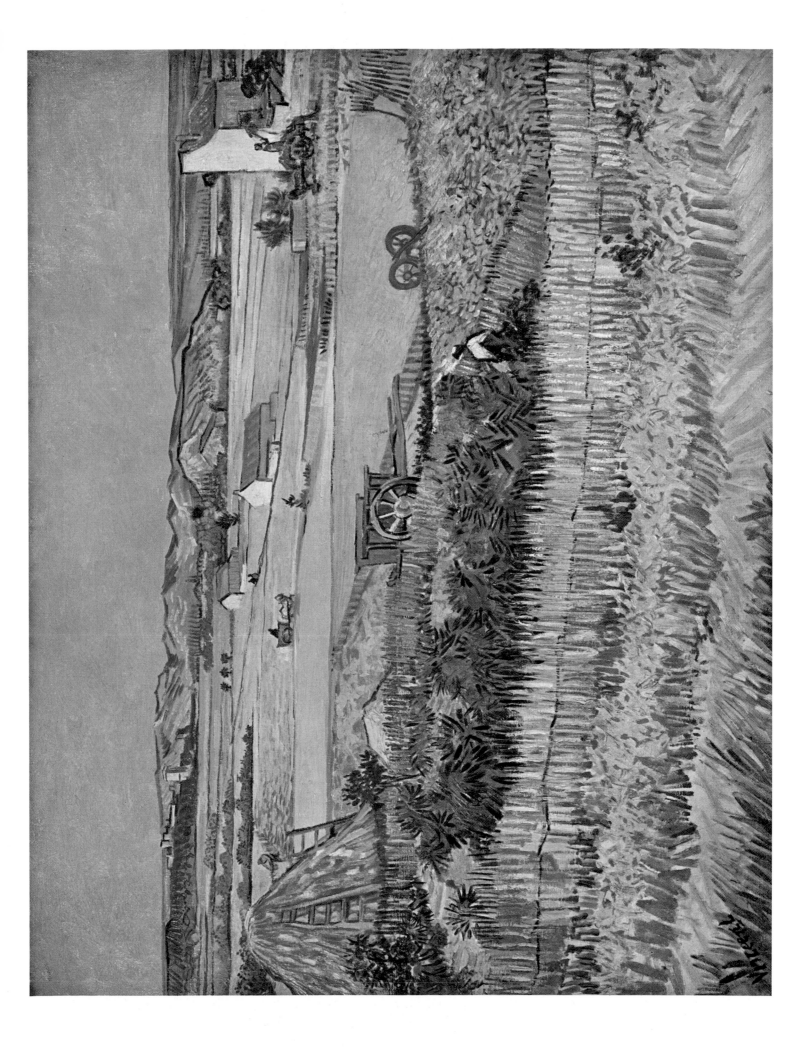

Haystacks in Provence

Oil on canvas, 73 x 92.5 cm. June 1888. Otterlo, Rijksmuseum Kröller-Müller

This painting of a Provençal farm with two huge hayricks was painted in June 1888 as a pendant to *Harvest at La Crau* (Plate 24). It calls to mind Van Gogh's earlier portrait of sheaves of wheat, painted in Nuenen in 1885 (Plate 2) when he was also preoccupied with cycles of rural labour and the seasons. The accompanying drawing (Fig. 27) is an example of a drawing made after a painting. Van Gogh had begun his artistic career primarily as a draughtsman, and drawing remained an important element of his work. Drawings were not merely preparation for painting and thus subordinate to it. They were independent exercises. This drawing demonstrates the rich vocabulary of graphic marks and designs which Van Gogh had been developing in his drawings in Arles concurrently with his explorations of colour. A variety of strokes and marks are used to suggest and evoke the different texture and character of each object. Van Gogh has used a reed pen in parts, in imitation of the tools used by Japanese draughtsmen. Indeed, he planned to collect many of these Arlesian drawings in a kind of album, the like of which he had read about in books on Japanese artists.

Fig. 27
Haystacks

Reed pen and ink on paper, 24 x 31.5 cm. June 1888. Budapest, Museum of Fine Art

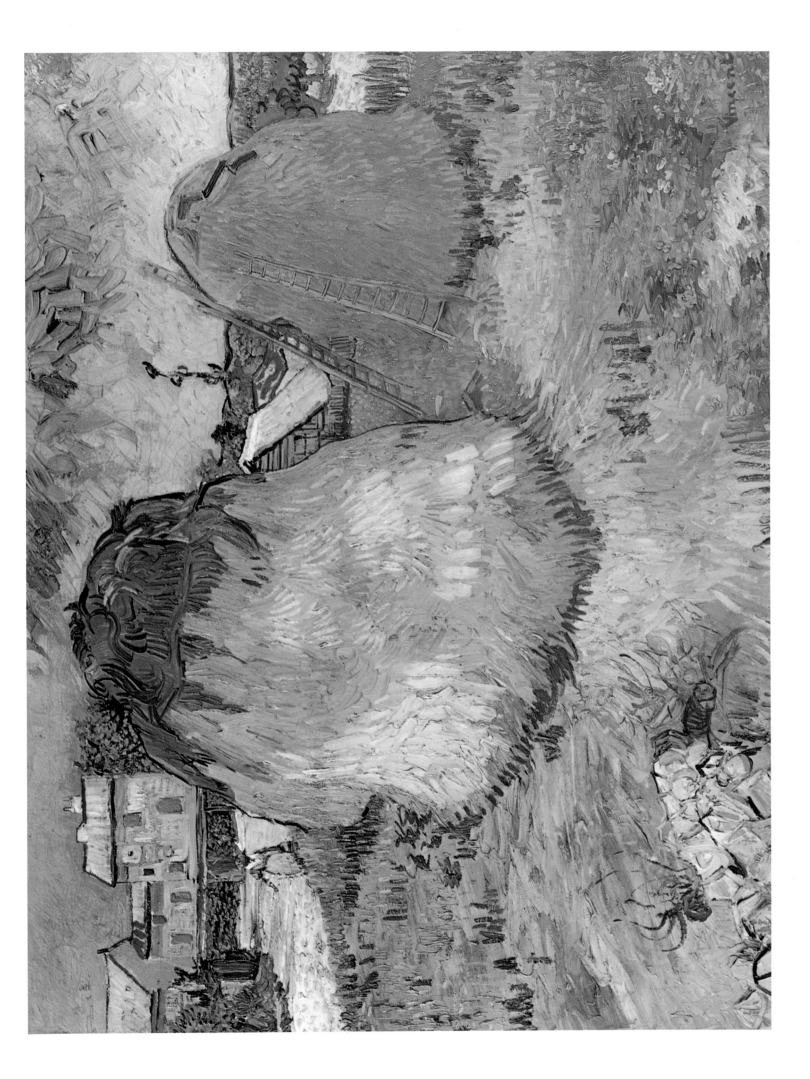

The Sower

Oil on canvas, 32 x 40 cm. Autumn 1888. Amsterdam, Rijksmuseum Vincent van Gogh

Van Gogh has painted an autumnal scene of sowing. The motif of the peasant sowing had fascinated him since his earliest months as an artist. In 1880-81 he had made many copies of an etching he owned after one of the most famous paintings of a sower by Jean François Millet, as well as composing his own drawings of the theme by posing local Brabant models as sowers. He returned to the subject in June 1888 when he painted a landscape with a small figure of a sower in a field, dominated by a huge sun (cf. Fig. 8). In letters written in June he referred directly to Millet's *Sower* but he complained that it lacked colour. It was one of Van Gogh's aims to correct this, in a sense to update the subject Millet had made so famous, and which was for Van Gogh so resonant, by repainting the motif using modern colour theory. The canvas was planned in yellows and violets, though it did not finally conform to that scheme. In the autumn he resumed *The Sower*, making two paintings, of which this one is a smaller and probably later version. He has used violet and yellow. The appeal of the sower motif for Van Gogh was complex. It signified Millet, and Van Gogh's allegiance to what he had stood for – rural themes in modern art; it signified the seasons and cycles of life and work. But it also referred to the Bible, especially the parable, a particular way of using a commonplace story to convey allegorical meaning. Finally it evoked modern literature, for instance Zola's recent novel *The Earth* (1888), which is structured round the cycles of sowing and harvesting. In July 1889 Van Gogh painted the complement to his sower, *The Reaper*, also in violet and yellow tones (Fig. 28).

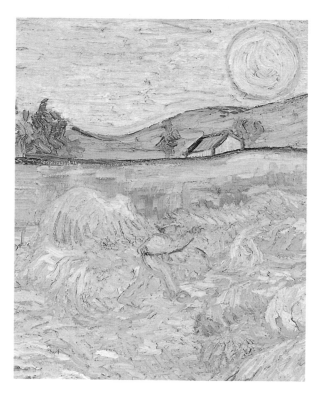

Fig. 28
The Reaper
(detail)

Oil on canvas, 73 x 92 cm.
July 1889. Amsterdam,
Rijksmuseum Vincent van
Gogh

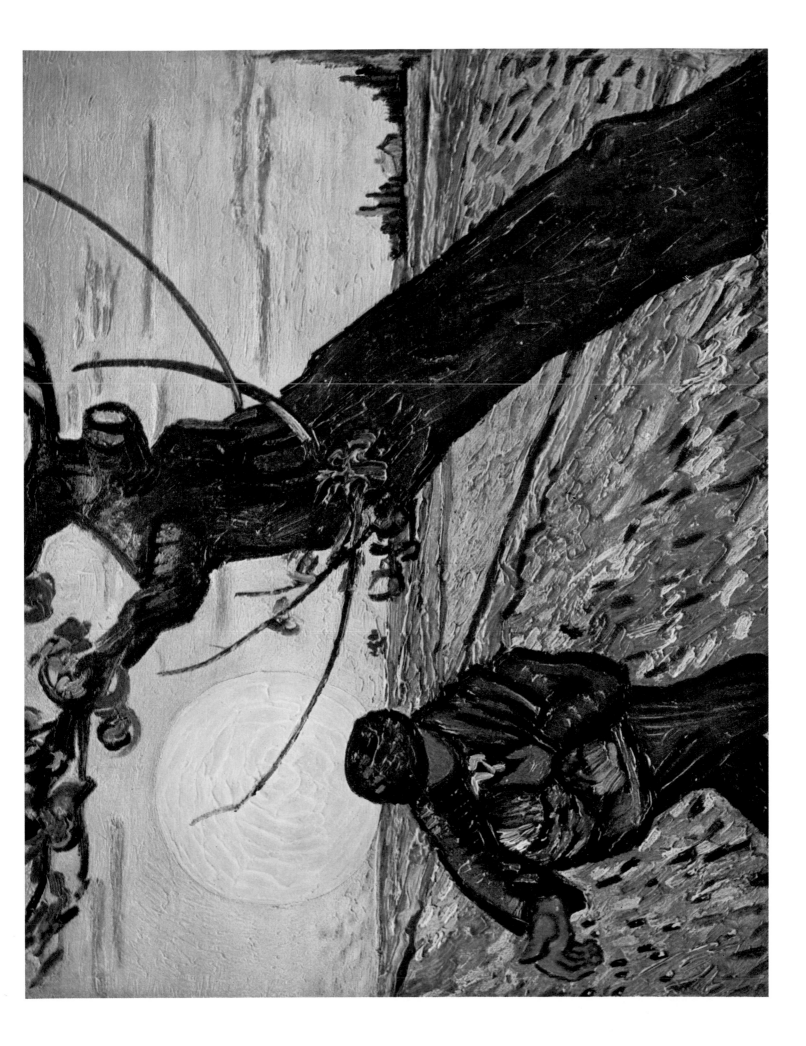

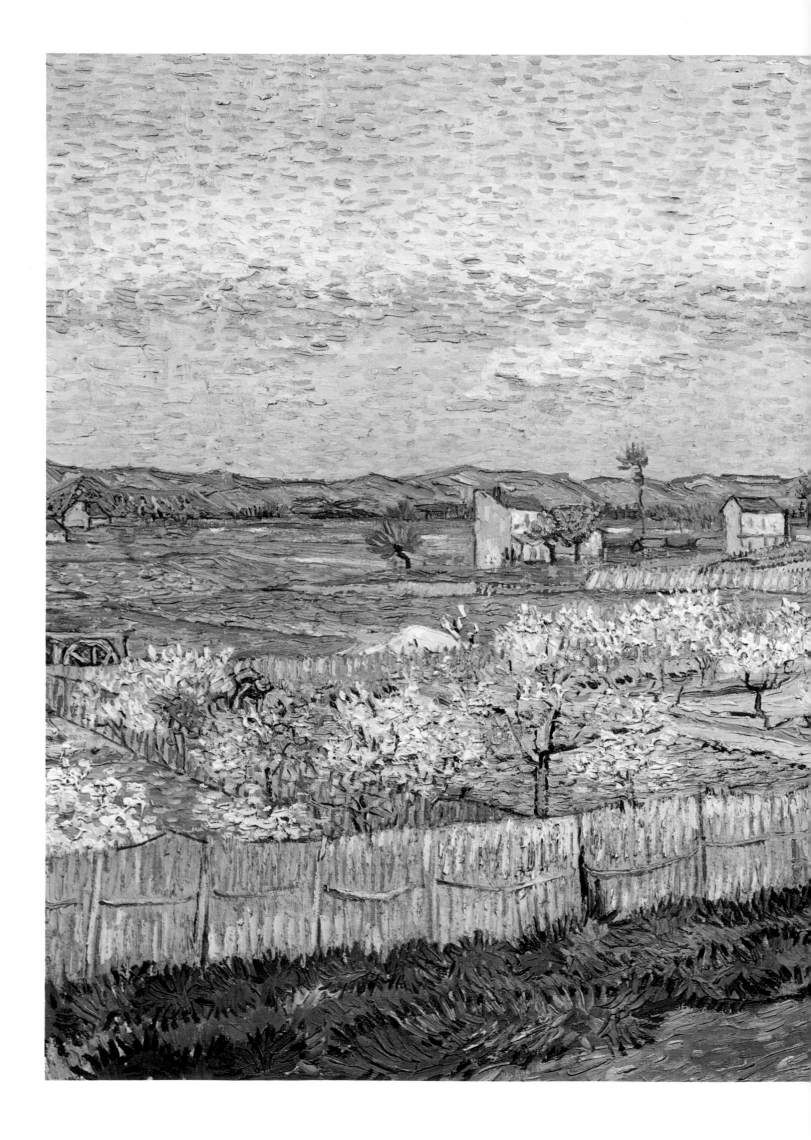

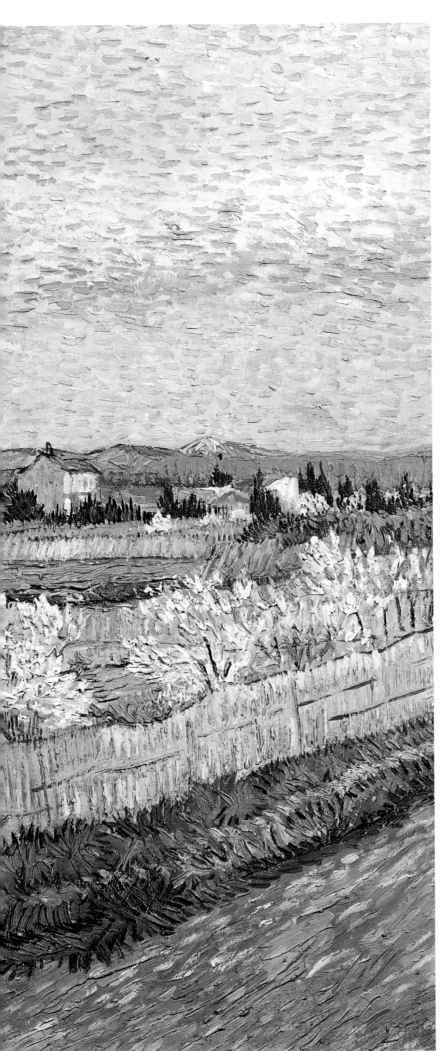

The Plain of La Crau with an Orchard 27

Oil on canvas, 65.5 x 81.5 cm. April 1889. London, Courtauld Institute Galleries

When spring came round again Van Gogh painted flowering orchards. This scene is painted on the same site as *Harvest at La Crau* (Plate 24) but the angle of vision is more oblique and less panoramic. The same blue cart is included, just visible on the left of the canvas. In a letter written to the Parisian painter Paul Signac, a Neo-Impressionist, Van Gogh explained: 'everything is small there, the gardens, the fields, the orchards and the trees, even the mountains, as in certain Japanese landscapes, which is the reason why the subject attracted me.' Orchards and snow-capped mountains in the distance are both motifs to be found in Japanese colour prints, such as those Van Gogh had used as a background for his portrait of Père Tanguy (Plate 7). Van Gogh had created for himself an image of Japan based in part on the woodcuts and in part on books by Western tourists to the Far East. He projected his vision of this imaginary country on to Provence in this spring version of La Crau, just as he had superimposed an image of an older Holland onto it in the harvest painting made in the manner of seventeenth-century Dutch pictures.

View of Arles with Orchards

Oil on canvas, 72 x 92 cm. April 1889. Munich, Neue Staatsgalerie

Shortly before Van Gogh left Arles he painted this view of the town, seen over the blossoming orchards and gardens and through a screen of tall trees. This image of the town differs from those he produced in the early months of his stay. Neither the agricultural environs of wheatfields nor the industrial landmarks of gas-tanks and railway lines are depicted. Instead we see an old, medieval Arles, surrounded by its cultivated and fertile gardens. The sense of enclosure and fruitfulness, dreaminess even, has parallels in the illustrations of the medieval devotional books of hours, such as the *Très Riches Heures* of the Duc de Berry. Van Gogh selected this painting, which he titled *Orchards in Bloom (Arles)*, for exhibition with the Belgian vanguard group *Les XX* in Brussels in 1890. He exhibited three times with the Parisian *Indépendants:* in 1888 he showed three paintings, in 1889 two, and in 1890 ten. To Brussels he sent four pictures: two canvases of sunflowers, a field of wheat at sunrise, and *The Red Vineyard*, which was bought by the Belgian artist Anna Boch. To accompany the exhibition the organ of *Les XX*, the magazine *L'Art Moderne*, published extracts from the lengthy and enthusiastic essay on Van Gogh by Albert Aurier, first published in January 1890 in the *Mercure de France*.

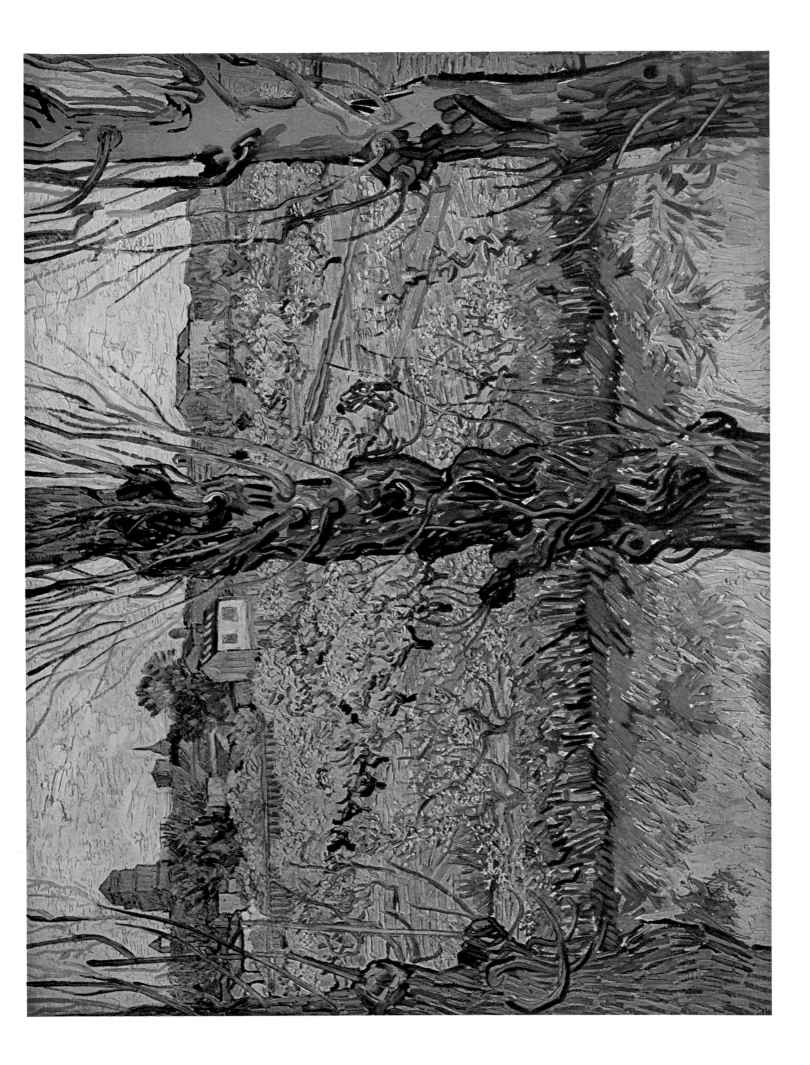

Madame Ginoux ('L'Arlésienne')

Oil on canvas, 90 x 72 cm. November 1988. New York, Metropolitan Museum of Art

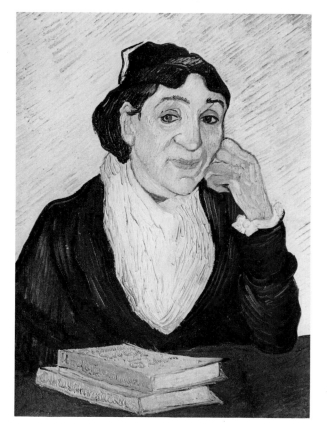

Fig. 29
Portrait of Madame Ginoux, after a drawing by Paul Gauguin

Oil on canvas, 65 x 49 cm.
January-February 1890.
Otterlo, Rijksmuseum
Kröller-Müller

Van Gogh's major ambition throughout his artistic career was to be a painter of the figure. He was hindered from realizing this desire by the inadequacy of his artistic education; he had not studied anatomy and other related academic preliminaries to a sufficient degree. Nor was he always able to afford to pay for the hire of models. Despite these drawbacks portraiture became an increasingly important component of his artistic production and a plank in his programme for modern art. By 1888 he was writing about the revolution in portraiture which he hoped would come, and he argued to Bernard that it was by the portrait that the vanguard would win the public over. The foundation of this conception of the portrait lay on the one hand in Van Gogh's reading of the critical writings of nineteenth-century French authors, who believed that seventeenth-century Dutch art, epitomized in its portraiture, was the beginning of modern art, and on the other in seventeenth-century Dutch portraits by Hals and Rembrandt, which Van Gogh had studied for himself as a result of his reading. He has painted this woman of Arles, resplendent in her local costume – itself reminiscent of the costume of Dutch seventeenth-century burgher ladies – in the format typical of Hals's and Rembrandt's portraits, against a plain background. Gauguin had drawn Madame Ginoux too and Van Gogh made a painted copy of his portrait in 1890 (Fig. 29), but he included two books, as he had in his own 1888 version. In the latter the titles are legible; one is Dickens' *Christmas Tales* and the other Harriet Beecher Stowe's *Uncle Tom's Cabin*. This practice was to become frequent in Van Gogh's portraiture. He relied on the added meanings introduced by literature to raise the portrait from a mere record of likeness to the desired status of figure painting.

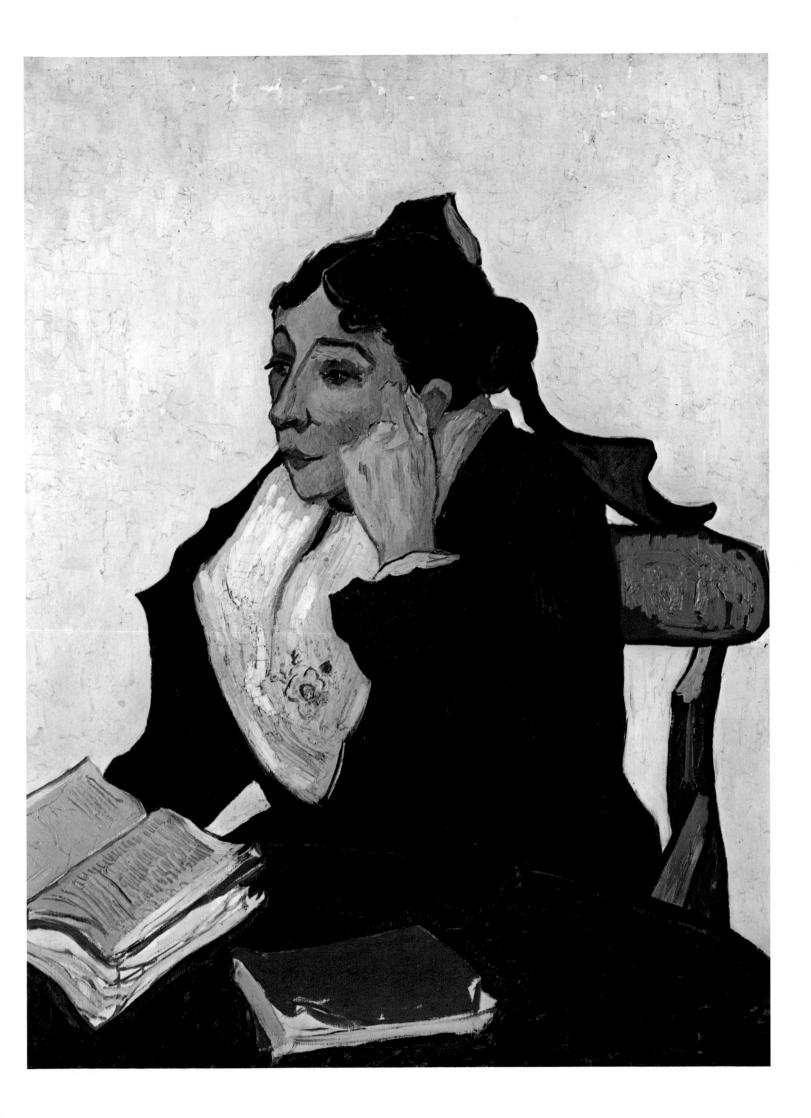

Portrait of Lieutenant Milliet ('The Zouave')

Oil on canvas, 81 x 65 cm. June-August 1888. Private collection

In Arles Van Gogh made the acquaintance of a Zouave, a soldier in the Algerian Infantry. He persuaded him to sit for three paintings and two drawings, and in return gave him advice on his painting. Van Gogh painted his friend in full Zouave uniform, brilliant in colour and exotic in style. He wrote to his brother of the difficulties he had encountered in managing the harsh and incongruous colours of the uniform, but explained that he liked to be working on vulgar, loud portraits such as this one. Van Gogh posed the vulgar and crude in opposition to the over-refinement and decadence of metropolitan taste in a letter written at this time about a portrait of a Provençal peasant (Fig. 11). The appeal of the Zouave as a subject for a modern portrait lay not only in his non-bourgeois and non-urban crudity but also in his association with the South. Milliet saw service in Algeria, which was for Van Gogh associated both with Delacroix and with the healthiness of a more primitive society. Van Gogh tried to persuade Emile Bernard to do his military service in Algeria on the grounds that it would help him regain his health and recover from the ill effects of metropolitan life and thought. Another possible significance for Van Gogh in this subject is the fact that Milliet was a soldier: had not Hals repeatedly painted the showy assemblies of the civic guards and officers, resplendent in their uniforms and high-coloured joviality?

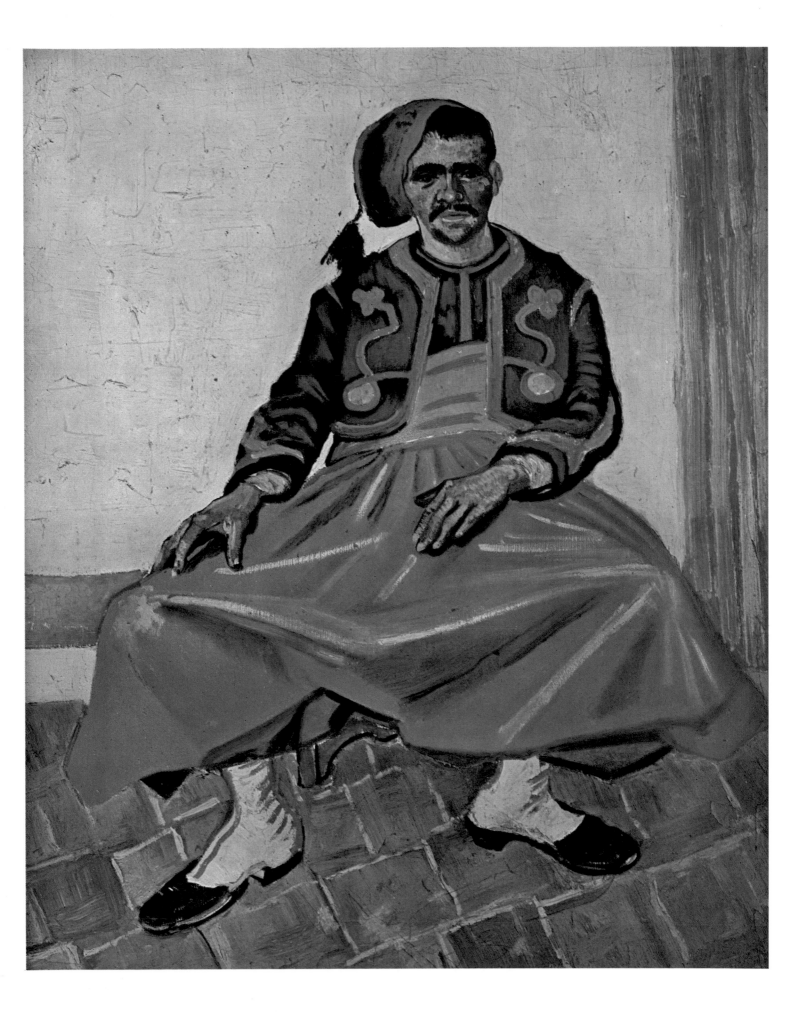

Portrait of a Girl ('La Mousmé')

Oil on canvas, 74 x 60 cm. July 1888. Washington, National Gallery of Art, Chester Dale Collection

In June 1888 Van Gogh had been reading a novel, *Madame Chrysanthème*, ostensibly about Japan, written by the popular and prolific Pierre Loti. Loti's descriptions of the young Japanese girl, known as *Mousmé*, much impressed Van Gogh, and he gave this portrait of an Arlesian girl the same Japanese title. Loti's travelogues and novels about his visits to Japan provided Van Gogh with a spurious picture of the Far East. Loti showed little insight into Japanese life and culture. They were seen through the eyes of a Western tourist, only for their Oriental exoticism and strangeness, by turns luxurious and primitive. Van Gogh, the Dutch tourist in Provence, seems to have viewed its life and people with as little comprehension. He took a superficial delight in what he saw as picturesque, quaint, different, and felt free to 'orientalize' a local Arlesian girl.

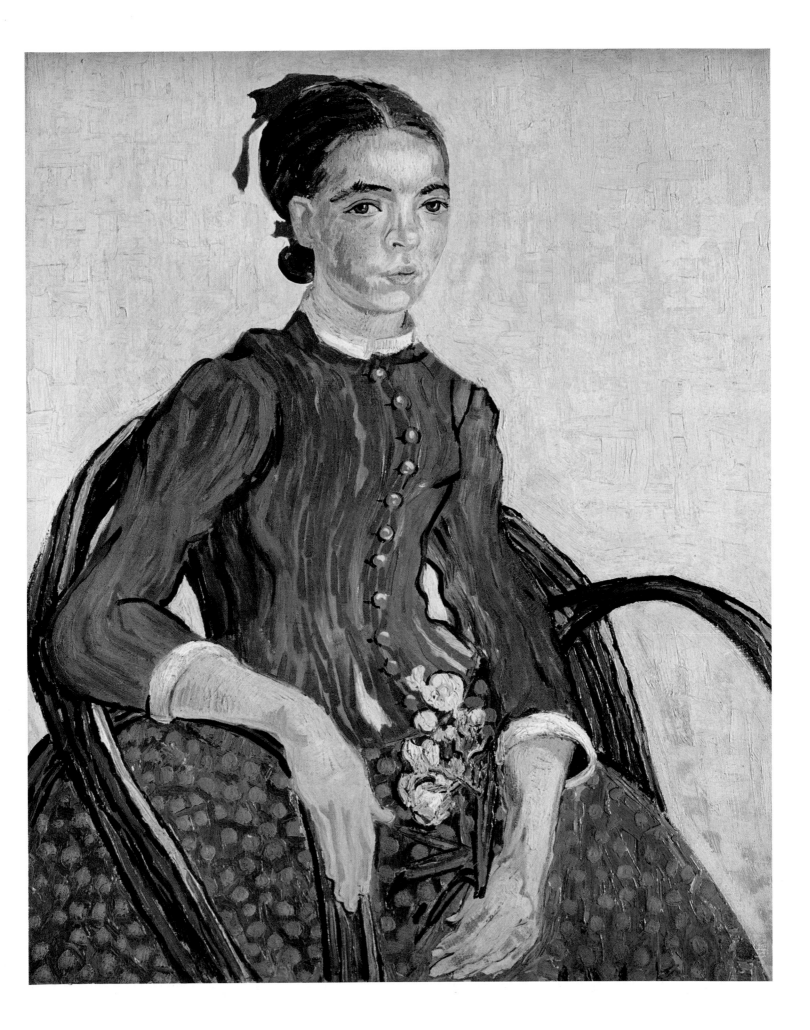

Portrait of Eugène Boch ('The Poet')

Oil on canvas, 60 x 45 cm. September 1888. Paris, Musée D'Orsay

In August 1888 Van Gogh told his brother of his plan to paint a picture of an artist friend – he called him a dreamer – using exaggerated colours. Instead of the plain background of an ordinary room, he would create the effect of a night sky, against which the head would stand out 'like the mysterious brightness of a pale star in the infinite'. This letter indicates the kind of meanings Van Gogh wanted portraits to convey. As ever, he did not feel constrained to attend to the specific identity or character of the person who sat as his model. In this portrait the Belgian Eugène Boch, a painter by profession, is portrayed as Van Gogh's image of a dreaming poet. He is simply shown, dressed in modern costume, but to the background stars have been added. Van Gogh later called the portrait 'Poet against a Starry Sky'. Boch is painted in a combination of brilliant yellows against deep blues. The placement of a man's head against the imaginative background of a starry night was meant to raise the portrait to the level of a more symbolic representation, the artist as dreamer, a statement about the artist's own dislocation from immediate social reality. The problem was that despite such ambitious ideas for the modern portrait, based on combinations of colour and assisted by symbolic attributes, Van Gogh could not convey such a burden of meaning without the ample textual explication he was obliged to offer in his letters.

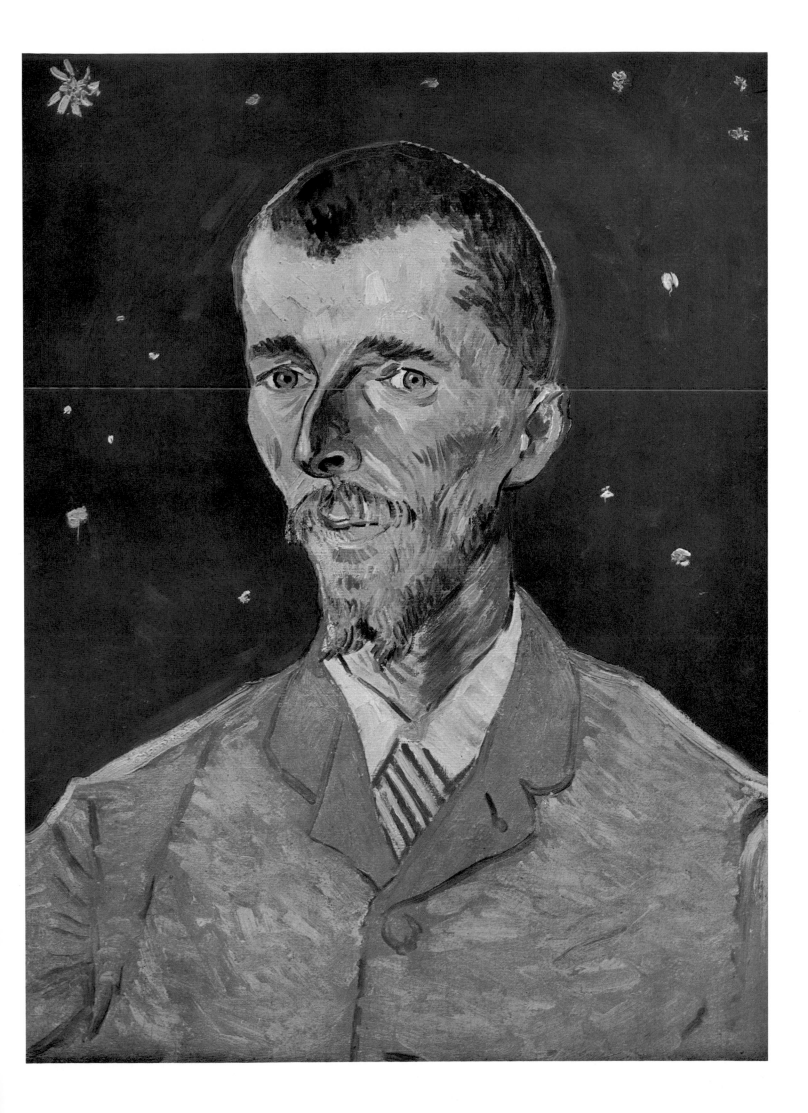

Portrait of the Postman Joseph Roulin

Oil on canvas, 65 x 54 cm. January-February 1889. Otterlo,
Rijksmuseum Kröller-Müller

In his letters to Emile Bernard Van Gogh often expounded his concep-
tion of the portrait, illustrating his argument with constant reference to
seventeenth-century Dutch portraiture. Hals and Rembrandt, he argued,
had been first and foremost portraitists, but not in the sense of mere pro-
ducers of facial resemblances. In their work, viewed as a whole, they pro-
duced a 'portrait' of a whole society, a lively, healthy and sane republic.
Van Gogh wanted to achieve a comparable social representation, but the
social relations of modern times were not as sane and healthy as in theirs.
His project was both reactionary and utopian, and inevitably more limit-
ed. So he planned to paint the family of the disaffected republican
Roulin, the postman. The project was conceived in the summer of 1888,
pursued during that autumn, and finally accomplished in 1889. His first
portrait of Roulin, a seated, three-quarter-length painting in which the
sitter is facing to our right, is close to the portrait of Madame Roulin
(Plate 34). She is also a seated, three-quarter-length composition, but
faces left. The format is that of the pendant pairs of marital portraits
common in seventeenth-century Dutch painting. The portrait of Roulin
illustrated here was painted after the final one of Madame Roulin but it
is linked with it, despite compositional differences, by the use of a deco-
rative floral background, against which the head is set.

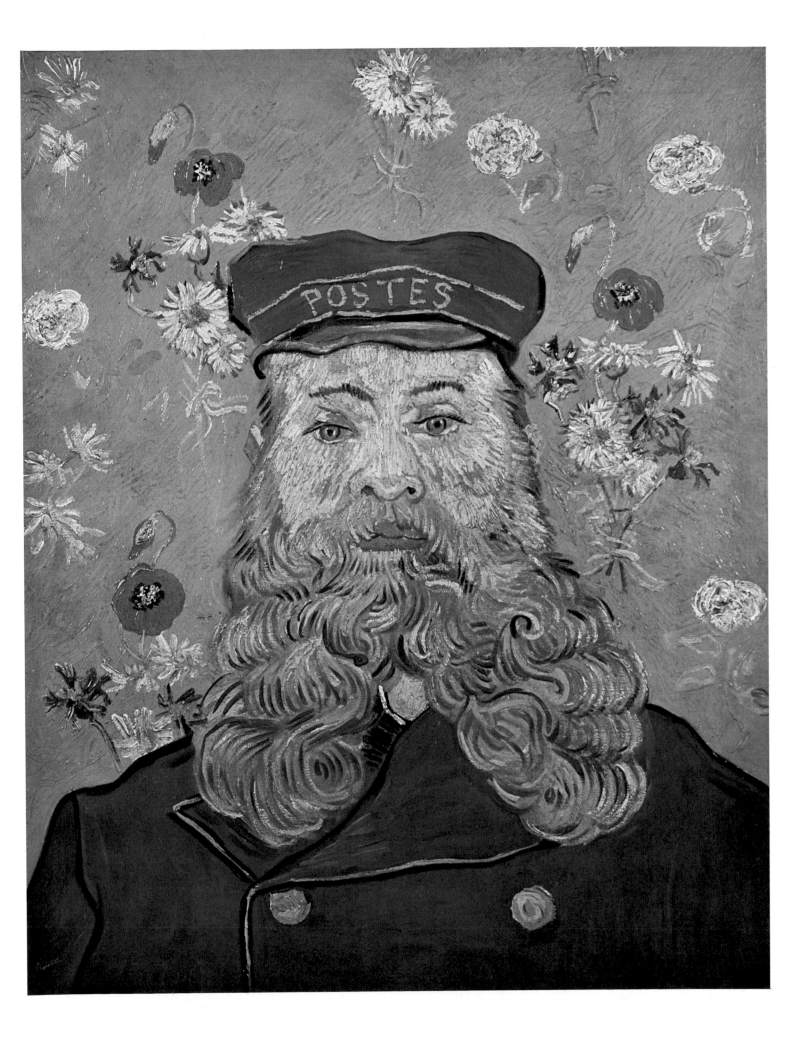

Portrait of Madame Augustine Roulin
('La Berceuse')

Oil on canvas, 92 x 73 cm. January 1889. Otterlo, Rijksmuseum Kröller-Müller

Fig. 30
**Sketch from Letter
592**

May 1889. Amsterdam,
Rijksmuseum Vincent van
Gogh

The portrait of the postman's wife, recently delivered of her third child, was planned in late 1888 but only completed, after some interruptions, in early 1889. The conception of the painting, originally one of the series of family portraits, changed as a result of Gauguin's visit in the autumn of 1888. In it Van Gogh examined an alternative strategy for infusing a portrait with complex meanings. He gave the portrait a title, *La Berceuse*, which can mean both the woman who rocks the cradle and the lullaby she would sing beside it. Madame Roulin is represented primarily as the mother; she holds a cradle rope between her hands. Van Gogh supplemented this reading of the work in his letters by mentioning another Loti novel, *Pêcheurs d'Islande* ('Fishermen of Iceland'), in which the author described the comfort and remembrances of home brought to isolated Breton fishermen by the crude old faience madonna that stood in the cabin of their fishing boat. *La Berceuse* was a significant work for Van Gogh. He painted five versions of it, one of which was taken by the sitter. He offered versions to Gauguin and Bernard and suggested a special setting for the painting, flanked by twin canvases of sunflowers whose brilliant yellow warmth was to underscore the feeling of gratitude which the painting was intended to convey (Fig. 30). However, when he later turned his back on Gauguin and Bernard and the ideas they had encouraged him to pursue, Van Gogh also rejected this portrait, one of the most elaborated and sententious he had produced.

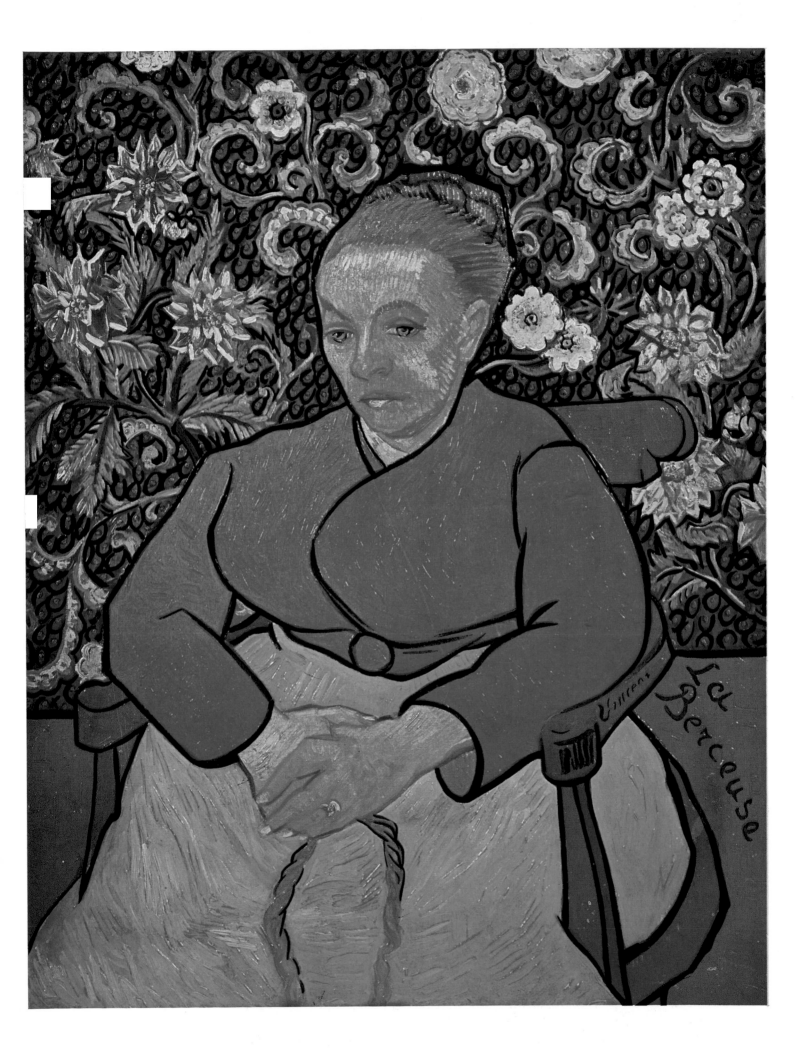

Portrait of Armand Roulin

Oil on canvas, 65 x 54 cm. November 1888. Rotterdam,
Museum Boymans-Van Beuningen

Fig. 31
Armand Roulin

Oil on canvas, 66 x 55 cm.
November 1888.
Essen, Folkwang Museum

Van Gogh painted two portraits of the Roulin's seventeen-year-old son, Armand. Both were completed in November 1888 but neither on the size of canvas originally planned. One (Plate 35) shows a young man in profile, dressed in a dark blue suit and matching hat; the other, probably the first version (Fig. 31), presents Armand Roulin full face, in a citrine jacket and contrasting hat and waistcoat of blue. Both paintings are very simple in their composition, presenting the young man without any additional details, decoration or scenery such as are provided in the portraits of the Roulin parents or in others where colour, setting or costume attempt to introduce layered meanings. What is remarkable in both these pictures is the seriousness of expression, which is almost sombre and sad. This effect of the features contrasts with Armand's almost dandyish dress, the rakish angle of his hat, and the carefully painted knotting of his cravat.

Still Life with Drawing Board and Onions

Oil on canvas, 50 x 64 cm. January 1889. Otterlo, Rijksmuseum Kröller-Müller

This cheerful still life was painted shortly after Van Gogh left the hospital in Arles which he had entered after his first major attack of psychomotor epilepsy on 25 December 1888. The objects depicted have both an allegorical and a more personal significance. The lighted candle, used in the painting of Gauguin's chair (Plate 18), derives from the emblematic tradition of still life and signifies light and life; its opposite, the snuffed-out candle, was used in *memento mori* still life and Van Gogh had included it in a still life with books which he painted after his father's death in 1885 (Amsterdam, Rijksmuseum Vincent van Gogh). The optimistic note sounded by the candle flame is underlined by the presence of the sprouting onions, taken from his 'self-portrait' (Plate 19), and also by the book – F.V. Raspail's *Annuaire de la Santé* ('Annual of Health'). On the other hand, Van Gogh has added his pipe and tobacco and an empty bottle, possibly once containing absinthe, all of which endangered his health. Modern research has intriguingly shown that absinthe itself can cause epileptic fits. Van Gogh had consumed this poisonous beverage in some quantity during the months in Arles, and many of his subsequent fits coincide with occasions on which he had access to it. The drawing board on which most of these objects are placed indicates Van Gogh's resumption of work. He informed his brother that he was painting still lifes to ease himself back into painting after his hospitalization. However, the colours used in this painting are more tempered and less intense, more controlled and less arbitrary than those he had been using both in the summer of 1888 and under the aegis of Gauguin in the autumn preceding his attack.

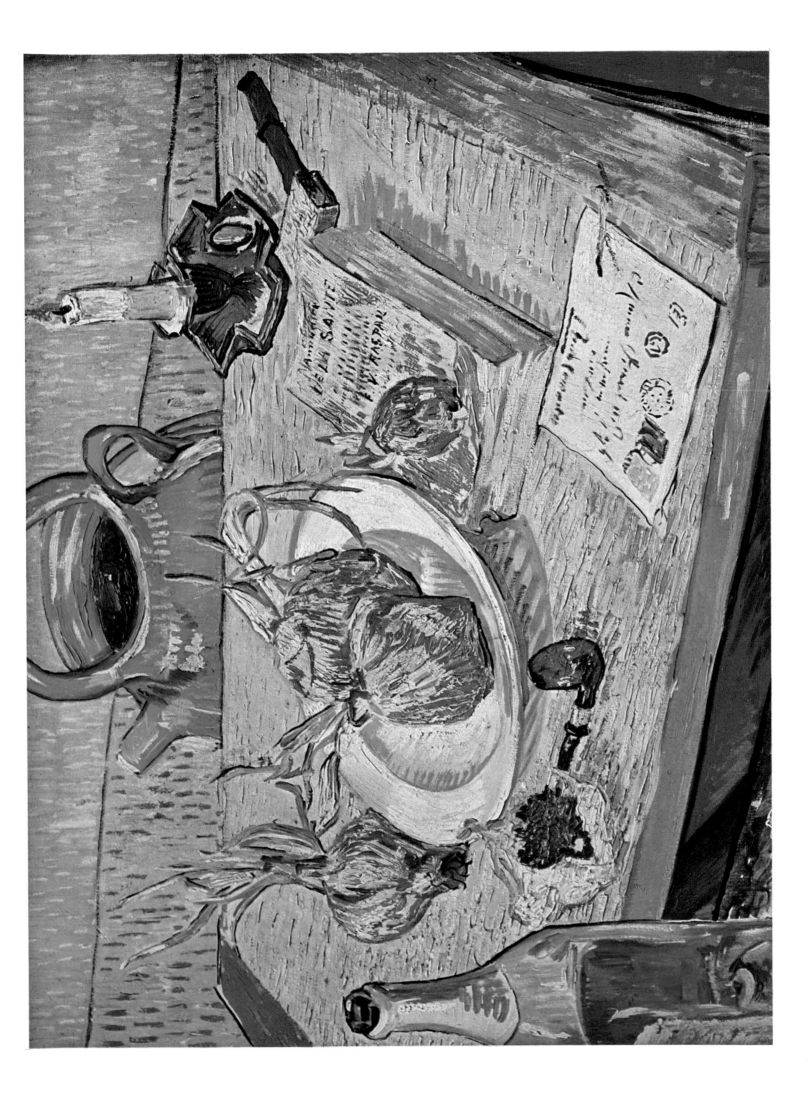

The Ravine

Oil on canvas, 72 x 92 cm. December 1889. Otterlo, Rijksmuseum Kröller-Müller

To escape harassment from local inhabitants Van Gogh left Arles in May 1889 and moved into a sanatorium, St-Paul-de-Mausole, in the nearby village of St Rémy. There he hoped he would be able to work quietly and have medical supervision in case of a recurrence of his epilepsy. St Rémy lay beside the Provençal hills known as the Alpilles, which are extraordinary geological formations, low-lying, rocky crags, weathered into grotesque shapes and pitted by ravines and waterchannels which have cut their way through the rocks. In the plains beneath them are fertile olive groves (Fig. 32). Van Gogh was fascinated by this novel landscape. He was often able to go out from the hospital and paint and draw these unusual surroundings. He developed a more sinuous, linear style in drawing and a more flowing manner in painting in order to represent their special shapes and features. In St Rémy Van Gogh gradually softened his palette too, entertaining the idea that in order to render his sense of the interrelation between the different elements of the landscape, tonality might be more appropriate than fierce colour contrasts. He cited the seventeenth-century artist Van Goyen in support of this redirection, and in connection with his painting of the ravine he mentioned to his brother that Jules Bakhuysen, a Hague School artist he had known in Holland, would understand his current point of view.

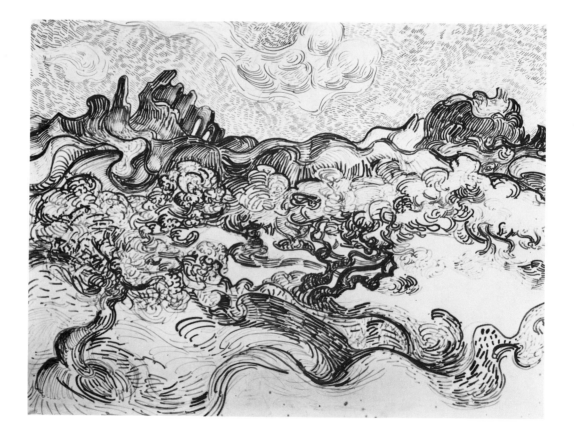

Fig. 32
Olive Groves in
the Alpilles

Pencil, reed pen and ink
on paper, 47 x 62.5 cm.
1889. East Berlin,
Nationalgalerie

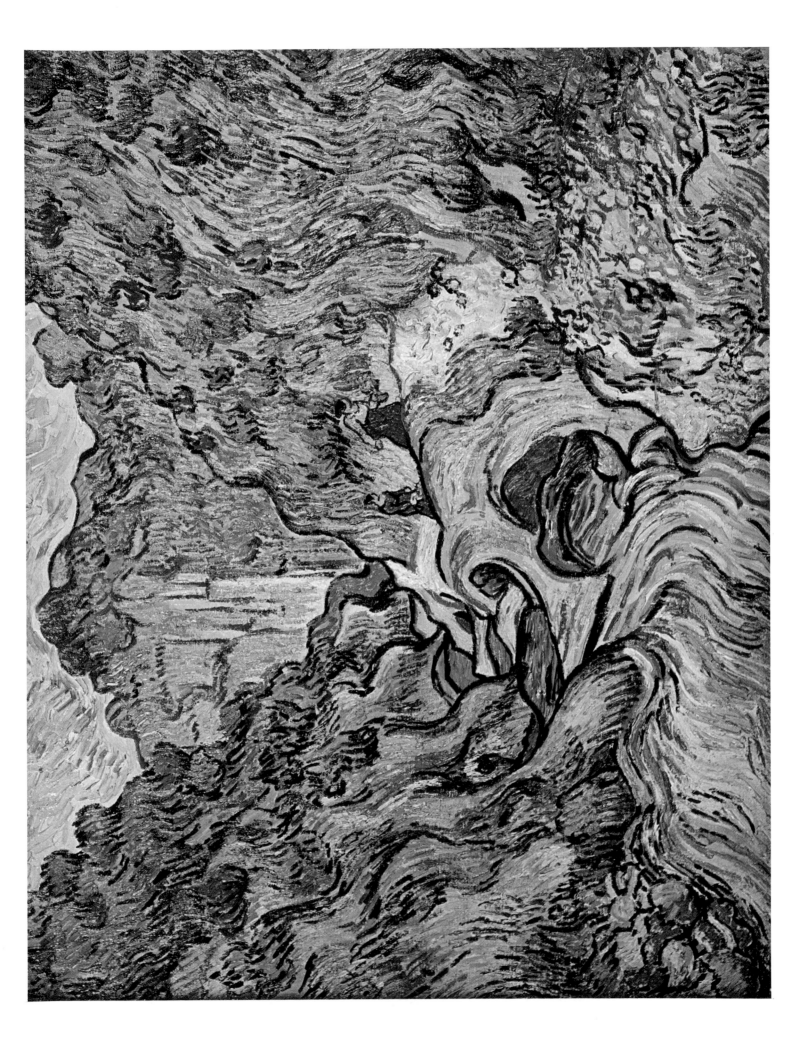

 # Fir-woods at Sunset

Oil on canvas, 92 x 73 cm. October-December 1889. Otterlo,
Rijksmuseum Kröller-Müller

In addition to many canvases of the Provençal olive groves, Van Gogh
painted 'portraits' of other kinds of trees typical of and epitomizing the
South, cypresses and fir-trees. His treatment of these weatherbeaten
trees against a sunset sky confirms his revived interest in the artists and
artistic tendencies with which he had been involved during his Dutch
period, especially Barbizon landscape painting and the work of Jules
Dupré and Charles Daubigny. Both of these artists were well known to
him from his years as an art dealer with Goupil and Company in The
Hague, Paris and London. They had been the models to which he had
turned when, in Drenthe, he attempted to make himself into a landscape
painter. Indeed the painting is a decisive reminder of a particular work by
Dupré, *Autumn* (The Hague, Rijksmuseum Mesdag), which Van Gogh
had seen and noted at an exhibition in The Hague in 1882 and in
imitation of which he had drawn a sketch of some old bog trunks at sunset
in the autumn of 1883.

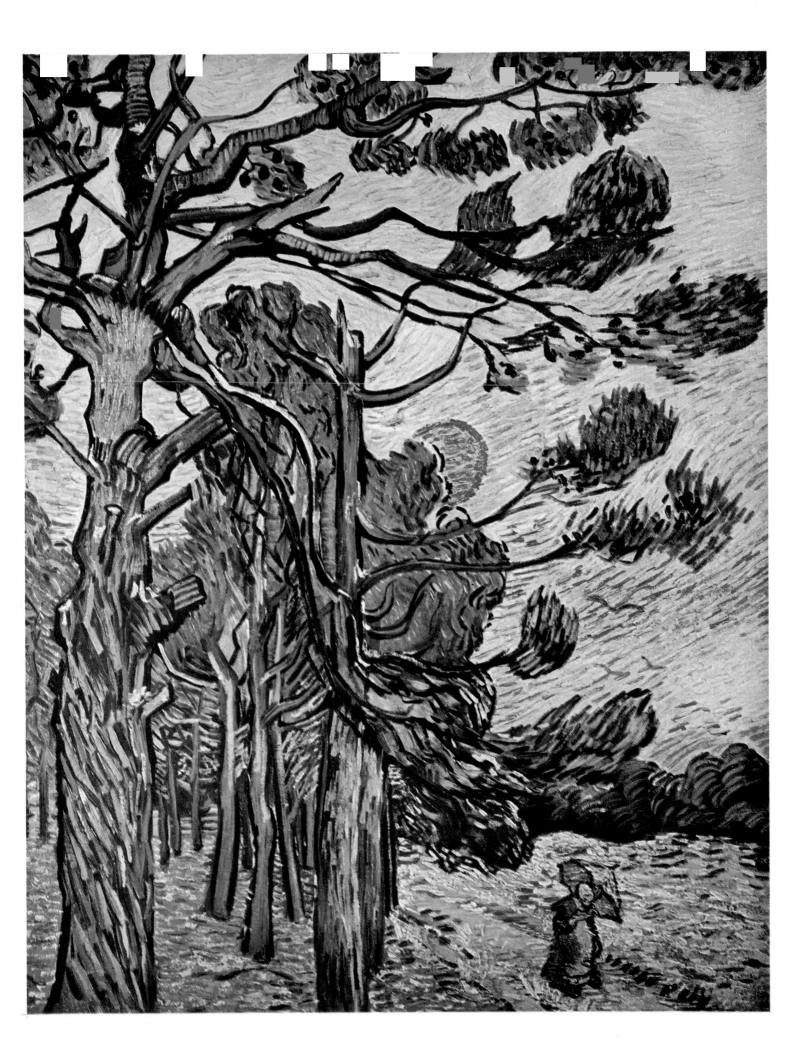

Oil on canvas, 72 x 93 cm. Spring 1890. Otterlo, Rijksmuseum Kröller-Müller

Van Gogh often painted this view from his hospital window at St Rémy, using the window itself as a sort of perspective frame. He had tried to master the laws of correct perspective by reading textbooks on the subject, and in The Hague he had had a perspective frame made (Fig. 33) to help him in achieving it. The device is merely an empty frame, across which a grid of strings is drawn. This grid is also drawn onto the canvas or page. The artist looks at the motif through the frame, siting the scene and its objects in relation to the strings and then drawing or painting them in a corresponding position on the squared-up page or canvas. The point at which the strings cross provides the vanishing point, an imaginary point of distance which should match, in a mirror-like fashion, the viewpoint of the spectator. By this means a three-dimensional scene is transferred to a two-dimensional plane, and the space, perceived from this artificial, single viewpoint, is organized to appear logical and coherent, a kind of window on the world. However, if, as Van Gogh was given to doing, the artist deviates from the single viewpoint, looking above, below, or to the sides of the perspective frame and thus incorporating many viewpoints, the effect can be quite disarming, as is the case in this painting. The foreground and background do not match. The foreground, painted as if the grass and poppies are immediately beneath our feet, seems to tilt and slide forwards and downwards, thwarting the intended planar recession to the infinitely more distant background. The deviations from traditional geometric systems for representing space, created by Van Gogh's unsystematic use of these systems, serve, however, to produce an effect of dynamic space and immediacy.

Fig. 33
**Sketch of a
Perspective Frame
from Letter 223**

1882. Amsterdam,
Rijksmuseum Vincent van
Gogh

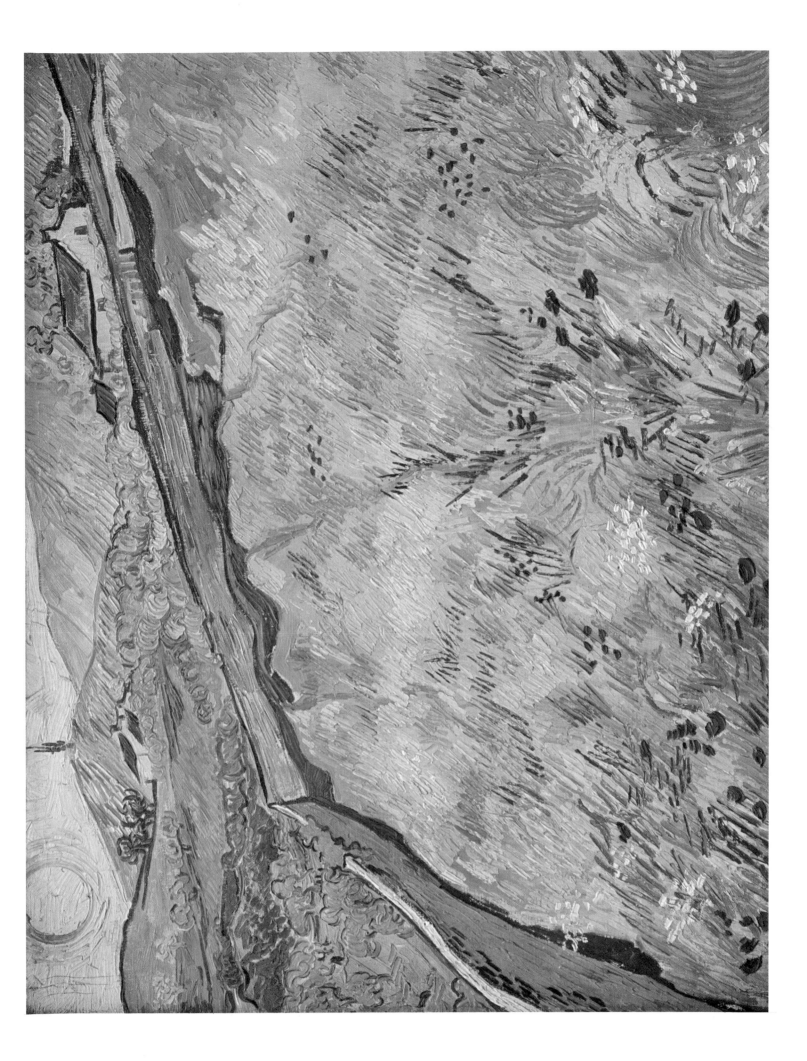

Oil on canvas, 29 x 36.5 cm. March-April 1890. Amsterdam,
Rijksmuseum Vincent van Gogh

Fig. 34
Peasants at a Meal

Black chalk on paper,
34 x 50 cm. April 1890.
Amsterdam, Rijksmuseum
Vincent van Gogh

Motifs such as wheatfields and times of the day had been part of the vocabulary of Van Gogh's art in his formative Dutch years. The important feature of his programme in St Rémy was his return to the preoccupations of that period and their justifications. He wrote to ask his family to send him drawings made in Nuenen so that he could rework them and work on similar themes. He planned to repaint *The Potato-Eaters* (1885), which he had always thought was his best and most important painting, and made drawings of its composition from memory (Fig. 34). He began a series of paintings of imaginary landscapes, based in part on sketches he had made in Drenthe and Nuenen and in part on his recollections of the rural architecture and the agricultural labourers of Brabant, which he called *Memories of the North* or *Memories of Brabant*. These drawings and paintings were not mere imitations of past work. Through them Van Gogh was asserting his allegiance to the ideas and meanings that such subjects, painted by himself and an earlier generation of French and Dutch artists, had carried – expressions of an attitude to the modern world. So he revived that subject-matter but revised it in terms of colour, and in drawing used the more sinuous, flowing and decorative graphic style that he had been developing in St Rémy.

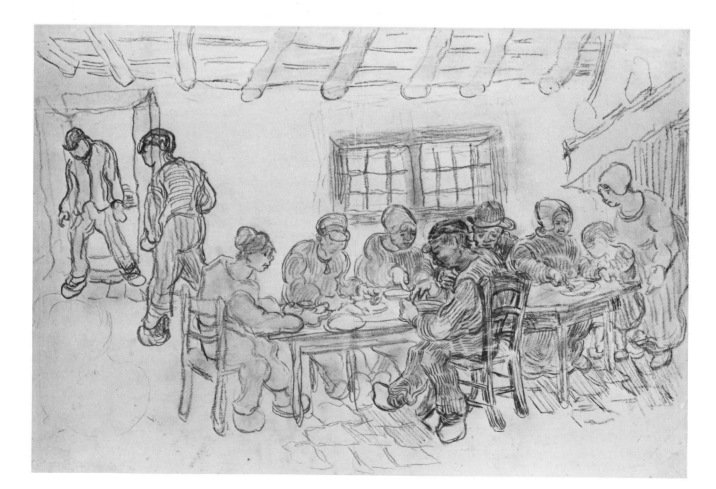

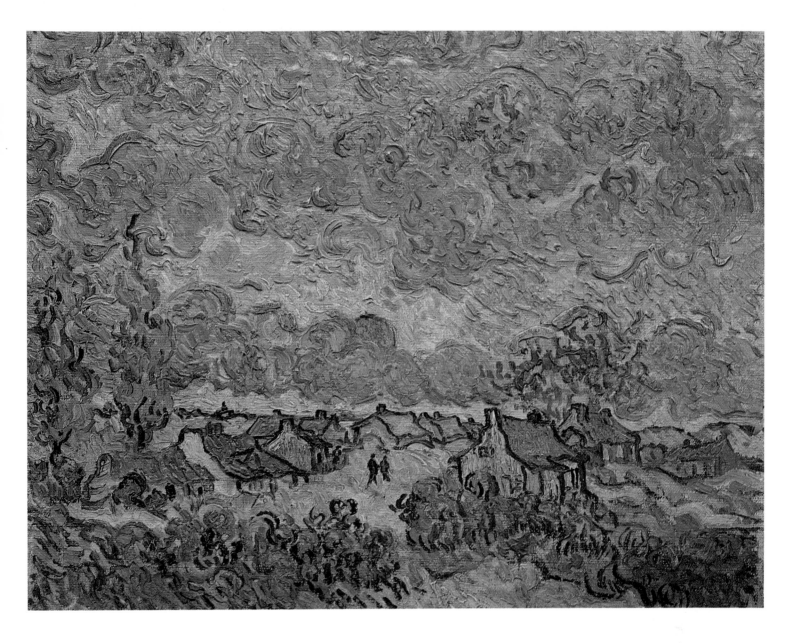

A Scene from The Raising of Lazarus, after the etching by Rembrandt

Oil on canvas, 48.5 x 63 cm. May 1890. Amsterdam, Rijksmuseum Vincent van Gogh

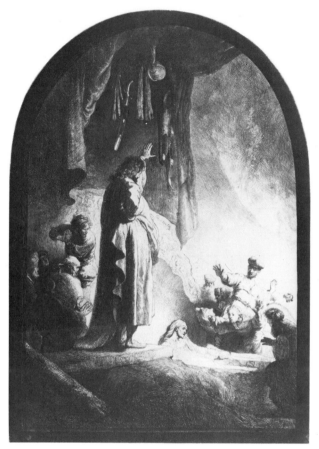

Fig. 35
Rembrandt van
Rijn: The Raising
of Lazarus

Etching. About 1632.
Reproduced by courtesy
of the trustees of the
British Museum, London

Another dimension of this new strategy of revival and revision was Van Gogh's interest in making copies in oil paint of prints by or after the works of those artists who represented for him the pantheon of modern art – Millet, Delacroix and Rembrandt, and Daumier, Doré and the illustrators. He explained these copies in many ways. At one level, in the absence of models, he used them to practise his figure drawing and painting. At another level, he stated that by painting them in colour he was attempting to bring these artists, and what they stood for, before the public once again. This also enabled him to update them by demonstrating what he identified as his contribution to the tradition of modern art – colour. Thus he claimed, with reference to his copy of Rembrandt's *Raising of Lazarus* (Fig. 35), that he was using colour to convey what Rembrandt had used chiaroscuro – tonal contrasts of black and white – to do. However, in the Rembrandt etching the pictorial device of light against dark was used to represent a religious theme; light emanates from the figure of Christ to dispel the surrounding darkness and thus depict the miracle of Christ raising a dead man. Van Gogh did not include the figure of Christ, and this omission precludes a religious reading of the image. Although there is a huge sun in the picture, it is not a pantheistic substitute; it is not a source of light. Van Gogh changed the setting of the scene by painting a wheatfield at sunrise in the background instead of a darkened tomb. In effect he was locating a motif from Rembrandt in one of his own landscape compositions and replacing an overtly religious subject with a genre painting of figures in a landscape.

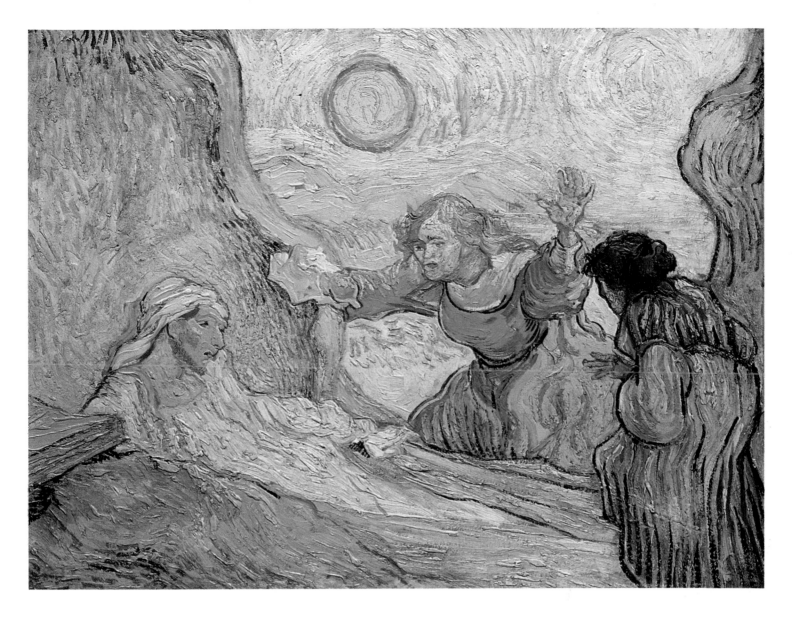

Road with Cypress and a Star

Oil on canvas, 92 x 73 cm. May 1890. Otterlo, Rijksmuseum Kröller-Müller

Why was Van Gogh investigating the roots of his practice at this date? This painting provides some clues. After leaving Holland and moving to France, Van Gogh had attempted to situate himself in relation to such Parisian painters as Bernard and Gauguin. He had corresponded and exchanged work with the former and, in a sense, studied with the latter in late 1888. He felt that they all three shared a dissatisfaction with Impressionism and its successors and a common purpose in creating what he called 'la peinture consolante' – painting of consolation. In June 1889 Van Gogh painted a picture he called *Starry Sky* (cf. Fig. 12), an imaginative composition, not painted from nature or the motif but composed from various sights and scenes of Brabant and Provence. He offered it to Bernard and Gauguin as his demonstration of a new form of religious painting. Both ignored the picture and thus overlooked Van Gogh's most ambitious painting in his French period, which had been conceived with reference to their joint concerns. Van Gogh responded to this cruel blow by angrily rejecting their work and the directions they had encouraged him to take. In June 1890, in a rare letter to Gauguin, Van Gogh mentioned *Road with Cypress and a Star* (Plate 42). He called it a 'last attempt' at a star painting. It shares many features and motifs with the disregarded *Starry Sky* (New York, Museum of Modern Art) – a crescent moon, stars in the sky, Brabant cottages with lighted windows, a tall, solitary cypress. But there is no church; the theme has been 'secularized', as had Rembrandt's etching (Plate 41; Fig. 35). It is just a landscape with cottages, trees, wheatfields and workers. It signifies a decisive retrenchment and a rejection of his flirtation with the Paris vanguard.

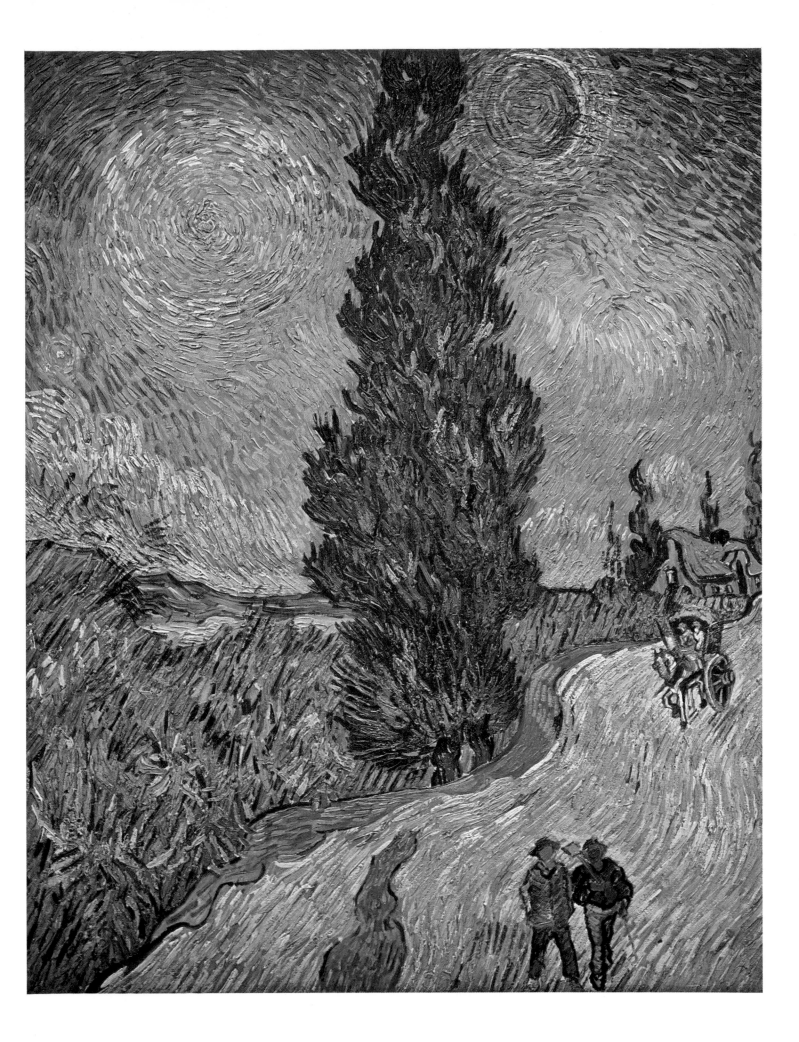

43 Portrait of Trabu, Attendant at St Paul's Hospital

Oil on canvas, 61 x 46 cm. 4-10 September 1889. Solothurn, Switzerland, Mrs. G. Dübi-Müller

Van Gogh was able to paint some portraits during his stay in St Rémy. The hospital attendant and his wife both sat for him, which is convincing evidence of his epileptic rather than psychotic condition. Who would leave his wife alone with a madman? The couple provided Van Gogh with another opportunity to paint a pendant pair of marital portraits. Of Madame Trabu's portrait Van Gogh wrote that he had painted her a faded, withered woman, like a dusty blade of grass. The colour scheme was pink and black and the mood is reminiscent of his images of ageing women in The Hague (Figs. 5 and 18). The attendant himself is portrayed with considerable force and presence in this bold and monumental portrait. The figure is placed frontally, set solidly in space against a background of delicately textured brushwork. The face is carefully painted with a different pattern of brushstrokes, which describe the contours of the forehead and skull and record all the cavities and slackness of the old man's ageing skin. The palette is softened and harmonious. As a portrait, it is one of Van Gogh's most masterful, technically accomplished and controlled. He described the sitter to his brother, delighting in the fact that he had 'something military in his small, quick, black eyes'.

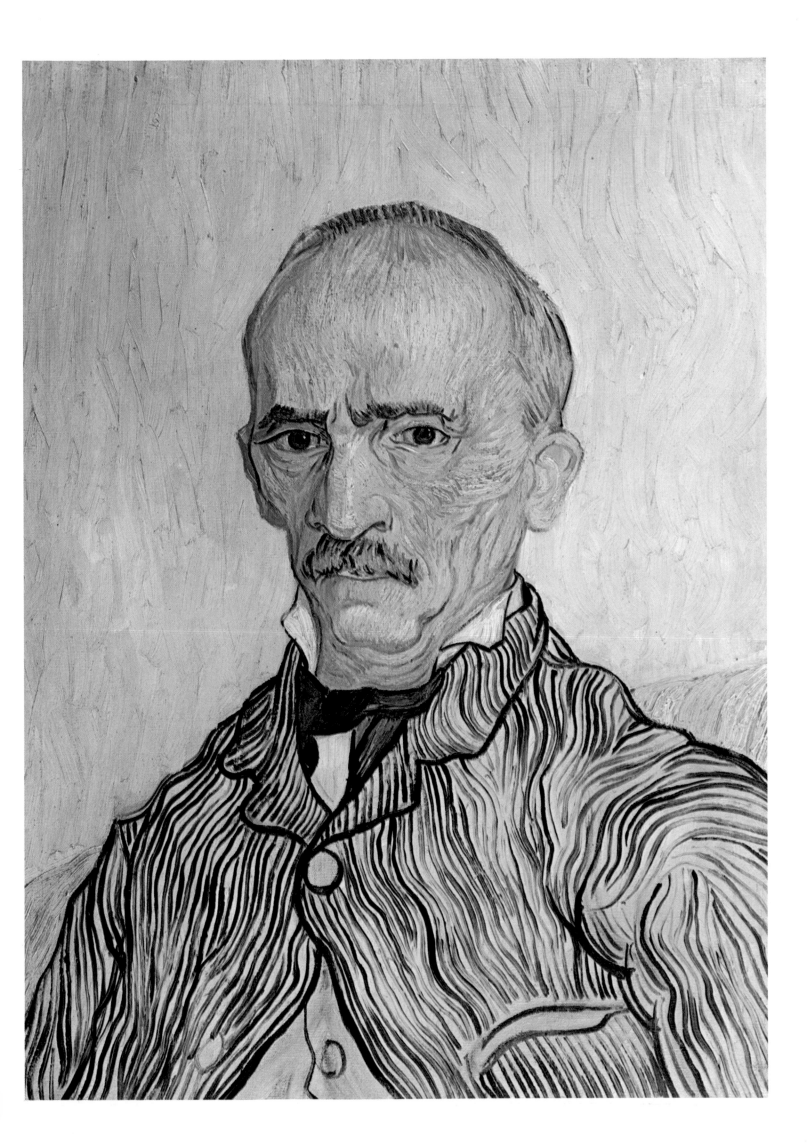

44 Self-Portrait

Oil on canvas, 65 x 54 cm. September 1889. Paris, Musée d'Orsay

The artist himself provided the most accessible of all models. Van Gogh painted himself twice in September 1889. In one of these self-portraits he shows himself as artist, dressed in his blue working smock, holding his palette and turning from his easel to stare at the spectator. The effect is lively and intense, partly as a result of the powerful blues and yellows in which he has painted himself. In the other portrait, illustrated here, Van Gogh appears before us dressed in a smart suit and waistcoat, without his professional attributes. The pose and coloration produce a calmer and more dignified portrait. The background is decoratively textured with its weaving of thick brushstrokes. It is more energetic than in the contemporary painting of Trabu (Plate 43). Apart from the white of the collarless shirt, and the flesh tones composed of pinks and delicate greens, the portrait is an exercise in blue and orange. Writing to his sister about this work and its companion, Van Gogh told her of the 'new' ideas about modern portaiture germinating in France. These were in fact his alone. The modern portrait was, according to Van Gogh, based upon the use of colour. But he also referred in his letter to the tradition of seventeenth-century Dutch portraiture, and it was from there that Van Gogh derived his idea of the portrait as an image of consolation, hope, calm and serenity. This self-portrait combines both threads.

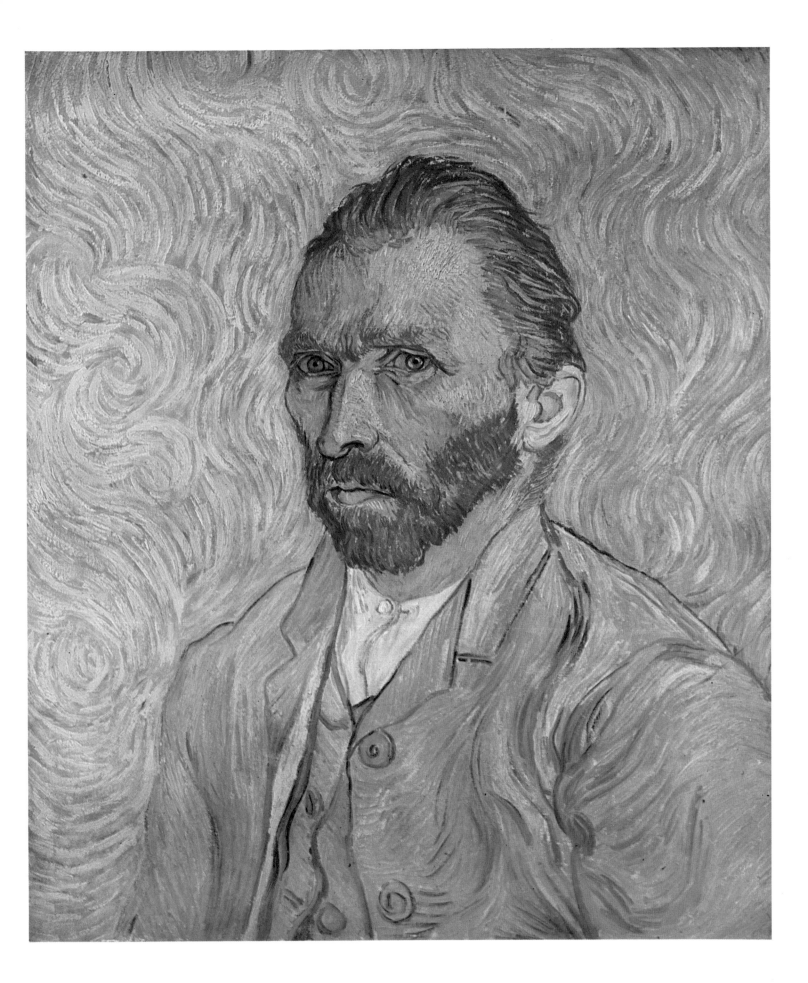

Still Life: Irises

Oil on canvas, 72 x 94 cm. May 1890. Amsterdam, Rijksmuseum Vincent van Gogh

In his last weeks at St Rémy before he moved north again, Van Gogh painted a series of still lifes. The size and scale of these recall the monumental paintings of sunflowers of the summer of 1888, but the disciplined use of complementary colours also establishes a link with the experiments in colour and in flower painting which absorbed him in his first year in Paris, 1886. In St Rémy he painted pink roses against a green ground, and here, violet irises against a yellow field. The painting betrays a renewed liveliness and intensity of colour. Instead of toning down the contrasts in order to harmonize the different parts of the painting, as he sometimes did, Van Gogh has tried here, as he had done in Paris, to sharpen and heighten them. He wrote: 'it is the effect of tremendously disparate complementaries which strengthen each other by their juxtaposition.' Van Gogh has painted these flowers on what was his preferred size of canvas in late 1888-90. The regular use of the same size of canvas meant that if and when his paintings were exhibited they would work together as a series.

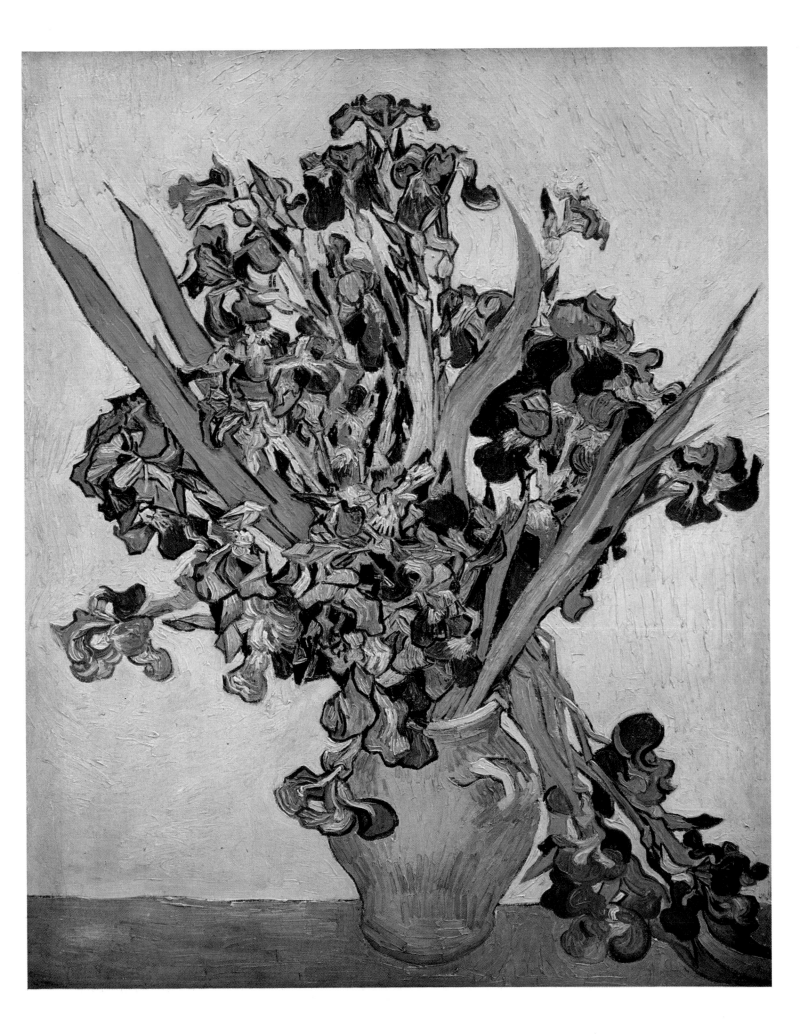

Portrait of Dr Gachet

Oil on canvas, 66 x 57 cm. June 1890. New York, private collection

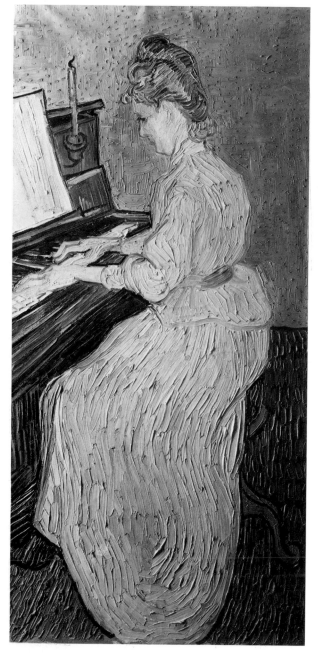

In May 1890 Van Gogh left the South of France and moved to a village forty miles outside Paris, Auvers. There he was very productive, painting over sixty pictures, and drawing a great deal before he wounded himself fatally and died on 29 July. Auvers had many connections with painters. Both Pissarro and Cézanne had worked there in the 1870s, and Dr Gachet, friend of Pissarro, amateur painter, and avid collector of modern French art, kept that link alive. Van Gogh's portrait of the doctor is a curious one. He claimed that it was intended to convey the heart-broken expression of modern times. Indeed the pose, head on hand, is a traditional representation of melancholy. There are other symbols and emblems. The foxgloves are thought to be a reference to Gachet's practice as a homeopathic doctor. The inclusion of two novels (in this case by the de Goncourt brothers) is not without precedent in Van Gogh's portraiture (Plate 29). Both of these novels are about Paris; *Manette Salomon* is in fact about a Parisian artist and his model. *Germinie Lacerteux* was the story of the tragic life of a domestic servant who fell disastrously in love. For Van Gogh, city life in general – and Paris in particular – was a place of melancholy and ill health. The country was its opposite, restorative and strengthening. The portrait of Gachet is an ambitious attempt to make a kind of historical portrait of modern man, suffering from the ill effects of urban life, from which there was no real escape but for which art could offer its unreal consolations.

Fig. 36
Marguerite Gachet at the Piano

Oil on canvas,
102 x 50 cm. June 1890.
Basle, Kunstmuseum

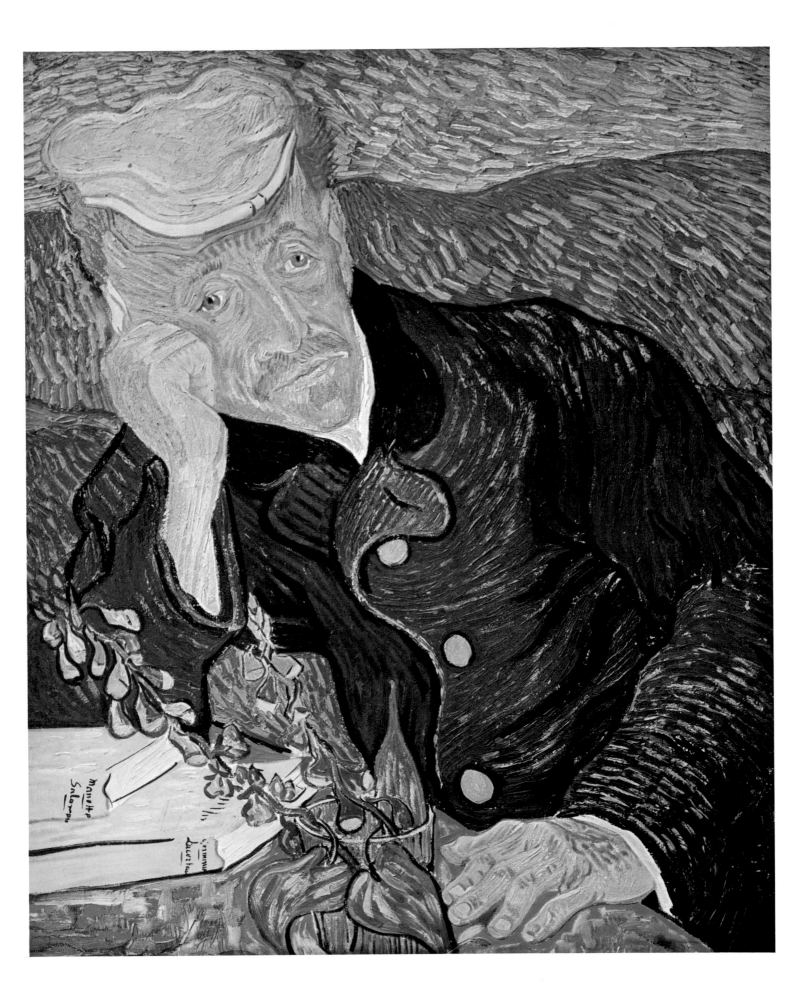

Daubigny's Garden at Auvers

Oil on canvas, 51 x 51 cm. Before 17 June 1890. Amsterdam, Rijksmuseum
Vincent van Gogh

Auvers had also been the home of a French painter of the generation before the Impressionists, Charles Daubigny. Van Gogh planned to paint a homage to the artist, who had figured so powerfully in his 'musée imaginaire' for the last two decades. He painted Daubigny's house and garden twice on a horizontal canvas; one of these versions was going to be sent to his brother Theo in Paris as one of a trio which would convey to that harassed city dweller the calm and restorative forces of the countryside. This unusual square canvas was possibly a study for those later versions. The format has the effect of precipitating the spectator into the garden and its riot of unkempt fertility. Yet the scale of the painting is such that the house itself seems very distant, almost screened off by the rows of trees, closed in on itself by its shuttered windows. This disordered space and uneven paint surface are none the less evocative. Van Gogh has almost used an Impressionist technique and palette to portray the garden of an artist who had been a bridge between the school of Barbizon and the early Impressionists. It was of Daubigny's work of the late 1860s that a critic loudly complained at the lack of finish, the sketchiness: his paintings were too impressionistic.

Landscape near Auvers: Wheatfields

Oil on canvas, 73.5 x 92 cm. July 1890. Munich, Neue Staatsgalerie

In the last weeks of July Van Gogh was working on pictures of familiar motifs, thatched cottages and wheatfields. In these late pictorial essays the problems of colour, space and texture, which had been so troublesome and unsatisfactory when he had first taken up such subjects, have been resolved. The considerable differences between this landscape and one of Drenthe (Plate 1) should not disguise an underlying relation. The significance Van Gogh attached to representations of agricultural scenes had changed little. In the inhabited and worked landscape of rural Brabant or France Van Gogh wanted to see signs of a way of life, a social order that was in his terms healthy, serene, more natural, timeless and organic, that was different from the world he inhabited, conflict-ridden, divided, and changing rapidly under the impetus of new economic and social forces. The motif from which this painting was made is the plain outside Auvers. It could as easily be Provence or Brabant; there is nothing specific about it. It tells us nothing particular about Auvers or its population and their ways of life or work. But by the organization of its colour, the combination of perspectives in the close foreground and the receding middle and far distance, the painting invites the spectator to contemplate fields, clouds, trees and haystacks, held pleasantly and harmoniously together, potentially extending beyond the limits of the frame to surround him or her.

Fig. 37
Plain at Auvers

Oil on canvas,
50 x 101 cm. June 1890.
Vienna, Kunsthistorisches
Museum

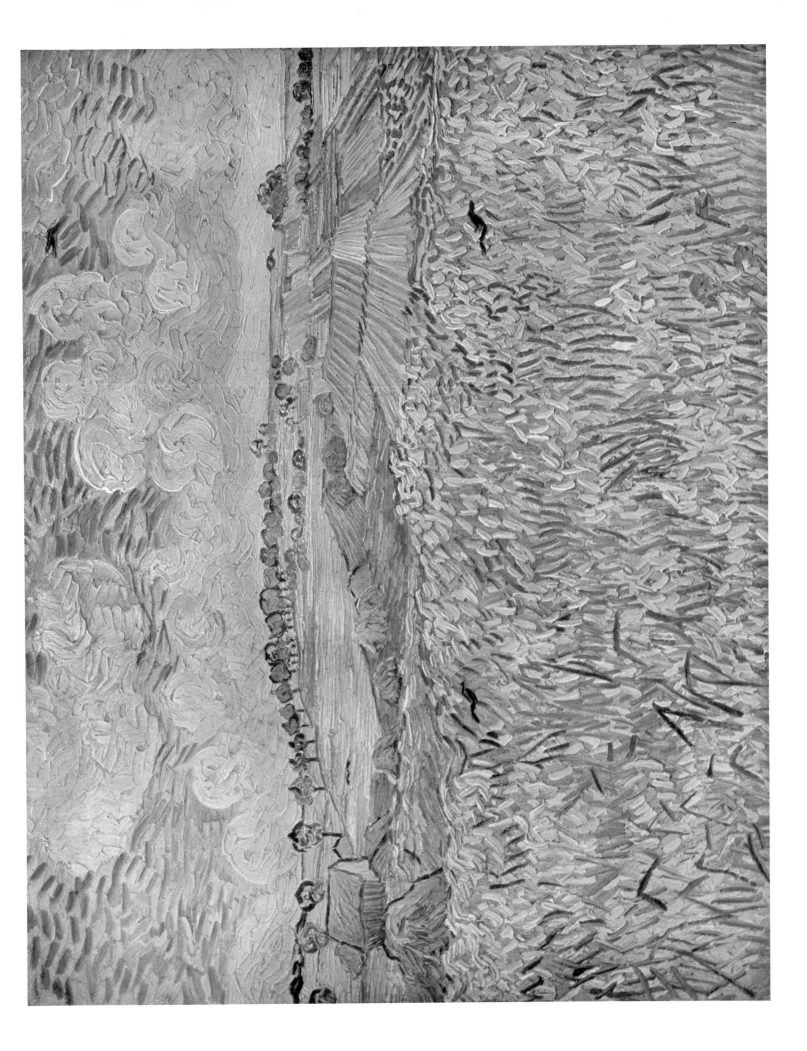

PHAIDON COLOUR LIBRARY
Titles in the series

FRA ANGELICO
Christopher Lloyd

BONNARD
Julian Bell

BRUEGEL
Keith Roberts

CANALETTO
Christopher Baker

CARAVAGGIO
Timothy
Wilson-Smith

CEZANNE
Catherine Dean

CHAGALL
Gill Polonsky

CHARDIN
Gabriel Naughton

CONSTABLE
John Sunderland

CUBISM
Philip Cooper

DALÍ
Christopher Masters

DEGAS
Keith Roberts

DÜRER
Martin Bailey

DUTCH PAINTING
Christopher Brown

ERNST
Ian Turpin

GAINSBOROUGH
Nicola Kalinsky

GAUGUIN
Alan Bowness

GOYA
Enriqueta Harris

HOLBEIN
Helen Langdon

IMPRESSIONISM
Mark Powell-Jones

**ITALIAN
RENAISSANCE
PAINTING**
Sara Elliott

**JAPANESE
COLOUR PRINTS**
J. Hillier

KLEE
Douglas Hall

KLIMT
Catherine Dean

MAGRITTE
Richard Calvocoressi

MANET
John Richardson

MATISSE
Nicholas Watkins

MODIGLIANI
Douglas Hall

MONET
John House

MUNCH
John Boulton Smith

PICASSO
Roland Penrose

PISSARRO
Christopher Lloyd

POP ART
Jamie James

**THE PRE-
RAPHAELITES**
Andrea Rose

REMBRANDT
Michael Kitson

RENOIR
William Gaunt

ROSSETTI
David Rodgers

SCHIELE
Christopher Short

SISLEY
Richard Shone

**SURREALIST
PAINTING**
Simon Wilson

**TOULOUSE-
LAUTREC**
Edward Lucie-Smith

TURNER
William Gaunt

VAN GOGH
Wilhelm Uhde

VERMEER
Martin Bailey

WHISTLER
Frances Spalding